DODGERTOWN

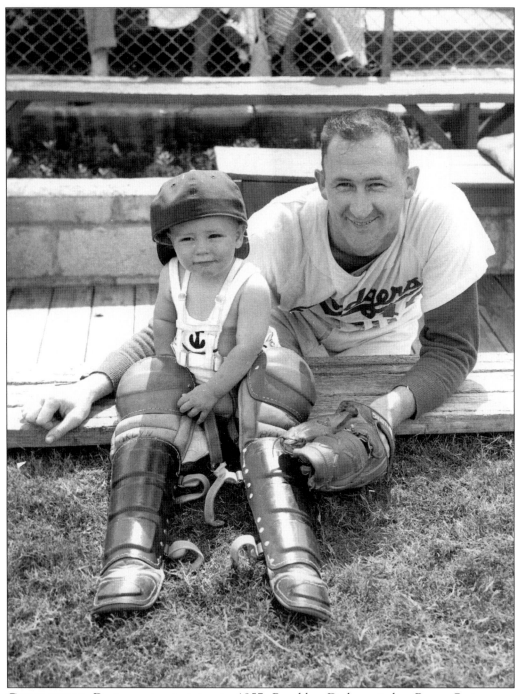

GENERATIONS. During spring training in 1957, Brooklyn Dodger pitcher Roger Craig poses with a top rookie prospect, Craig's one-year-old son Roger Jr. The elder Craig pitched 12 seasons in the majors and later became a major league manager.

DODGERTOWN

Mark Langill

ARCADIA

Published by Arcadia Publishing
Charleston SC, Chicago IL, Portsmouth NH, San Francisco CA

Printed in Great Britain

Library of Congress Catalog Card Number: 2004108889

For all general information contact Arcadia Publishing at:
Telephone 843-853-2070
Fax 843-853-0044
E-mail sales@arcadiapublishing.com
For customer service and orders:
Toll-Free 1-888-313-2665

Visit us on the internet at http://www.arcadiapublishing.com

For Astrid Omdal, Linda Sanday, and Natalie Langill—three generations of family "managers" who always take care of their home teams.

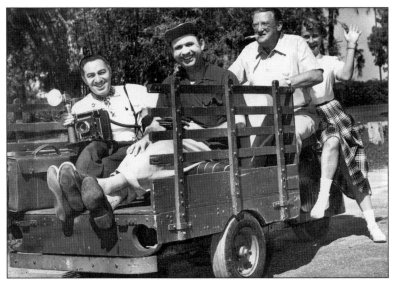

CANDID CAMERA. Chronicling the activities of spring training at Dodgertown were two of the most respected photographers in sports (from left to right) Barney Stein and Herb Scharfman. Stein began covering the Dodgers in 1939 and he collaborated with broadcaster Red Barber in the 1954 book, *The Rhubarb Patch: The Story of the Modern Brooklyn Dodgers.* Scharfman was a longtime photographer and the photo darkroom at the Vero Beach complex is named for him. Going along for the "ride" in this snapshot are Dodger president Walter O'Malley and his daughter Terry.

4

CONTENTS

ACKNOWLEDGMENTS

This book would not be possible without the special assistance and expertise of Robert Schweppe and Brent Shyer at O'Malley-Seidler, LLP in Los Angeles. Both Schweppe and Shyer are former members of the Dodger front office. Their personal recollections and enthusiasm for the team's history also made walteromalley.com—the official web site of the former Dodger president, which launched in October 2003—a treasure trove of information for generations of baseball fans and scholars.

Also, special thanks to Joe Hendrickson, the retired *Pasadena Star-News* sports editor whose daily reports from Vero Beach were of great interest to this author at a young age. Through his generous friendship, Joe offered encouraging words to a budding sportswriter, along with a draft of his unpublished Dodgertown manuscript that chronicled not only the history on the field, but also the personalities and behind-the-scenes efforts of employees who gave a designed baseball factory its heart.

Although tradition is an important component to Dodgertown, Dodger vice president Craig Callan faces the daily challenge of operating a modern-day tourist attraction and conference center while remaining committed to his work in the Vero Beach and Indian River County communities. Callan continues the legacy of blue-chip Dodgertown directors entrusted with keeping the camp's level of excellence, beginning with Spencer Harris in 1948. Callan's full-time staff includes Nancy Gollnick, Rich Nalbandian, Trevor Gooby, Keith Smith, Kathy Bond, Vicki Hahn, and Eileen Ganser.

The Dodgertown drivers also serve as goodwill ambassadors as they transport guests every day from the camp to various airports, along with the game-day staff, which adds to the ambiance of a visit to historic Holman Stadium. Countless other employees have contributed during the past 50 years, from maintenance to medical staffs. And a tip of the cap to the thousands of minor leaguers who never reached the majors, but the legacy of their hope and aspiration conjure the annual spirit of spring training.

Along with the players, coaches, and front office staff at Dodger Stadium in Los Angeles, special thanks to those who have contributed to the author's appreciation for Vero Beach during the past 15 years: Terry Johnson, Matt McHale, Herb Scharfman, Jon SooHoo, Ben Platt, Ken Gurnick, Randy Hill, Kevin Bronson, Bob Wall, Joe Baldo, Jim Pells, Ken Minyard, Dick Robinson, Bud Furillo, Rody Johnson, Reece Rogers, Derrick Hall, John Olguin, Geoff Witcher, Tom Bowman, Eric Tracy, Stu Nahan, Paul Gomez, Crystal Reid, Bill Plaschke, Terry Collins, Chris Haydock, and Luchy Guerra.

INTRODUCTION

It was a quiet February morning in 2004 when new Dodger owner Frank McCourt addressed the full squad of players, coaches, and other major league staff during the first full day of spring training in Vero Beach, Florida. The meeting was tucked away in left field as the players sat quietly on benches, shaded by the large trees behind the field's perimeter. Field No. 1 at Dodgertown represented the oldest existing playing surface at the Dodgertown complex, where the Brooklyn Dodger minor leaguers, in 1948, made an abandoned World War II naval air station their new home, complete with wooden barracks to sleep in at night.

McCourt welcomed the players and offered his background and the details leading to his purchase of the Dodgers. Although his family background was real estate development and construction, McCourt's grandfather once owned part of the National League's Boston Braves and baseball became a passion within the family. There is a newspaper photo preserved in the family scrapbook showing McCourt's mother sitting in the grandstands with her friends at the 1948 World Series, ready for a day at the ballpark. The Boston native also introduced his wife, Dodger vice-chairman Jamie McCourt, and professed his optimism for the upcoming season.

After the meeting, coaches grabbed their clipboards with their working groups and assignments as players gravitated into military formation for the stretching exercises. A similar scene would be repeated for the next six weeks in every spring training camp from Florida to Arizona. In addition to being a forum to physically prepare as a group, spring training provides a rare stage for players to truly enjoy a child's game at an innocent pace.

Spring is a chance to be silly when posing for baseball-card pictures, set personal goals, mentor a fresh-faced prospect lost in the minor league clubhouse, or secretly practice your autograph in the event anyone ever asks. The established superstars don't want to talk about last year's success, knowing there will be columns of zeros next to their names come Opening Day.

And for the fans, this isn't the time for face painting or pledging allegiance at the top of one's lungs. Such hollering isn't required because the exhibition games don't count. And even the most die-hard supporter would be pressed to offer any substantive detail of a Single-A shortstop's career when he appears as a pinch-hitter in the late innings and wearing uniform No. 86 on his back.

No training camp in the major leagues can compare to Dodgertown in terms of its history and traditions. The street signs honor the Hall of Fame players and broadcasters, the photos sprinkled around the complex are reminders of the memorable personalities who visited, whether for a couple of weeks or two decades. Long before he became a famous manager and proclaimed to

"bleed Dodger blue," Tommy Lasorda was simply one of 600 minor leaguers in camp, a left-handed pitcher hoping to catch the attention of the management and move up the ladder.

"I came to the Dodgers in 1971," said former Dodger pitcher Al Downing. "What struck me about Dodgertown was that it was an older complex at the time, but it didn't really reflect the attitude of the players or the organization. I think what the barracks really represented was unity. Everyone stayed in the barracks, even the owner. Evening, you walked down the road to where the restaurant was and it gave you a time to reflect. Then, you'd walk back to the barracks and guys shot pool in the barracks. That was your home away from home. No matter who you were, you stayed in those barracks. I think that probably was one of the things that provided the cohesiveness to this organization."

During the Dodgers' tenure in Vero Beach, the landscape of the major leagues has changed dramatically in terms of franchise shifts, expansion, labor disputes, and free agency. The Dodgertown complex, too, has varied its focus over the years. Once a "baseball only" facility, the camp became a training facility for the New Orleans Saints and other playoff-bound NFL teams wanting to take advantage of the warm weather, and offers a quality conference center for private businesses.

Like any marriage, the relationship between Vero Beach and the Dodgers has had its share of squabbles. It began right off the bat when there was a question as to whether Vero Beach or the Dodgers should pay for the construction of the swimming pool. A debate in the mid-1960s centered on the Dodger financial contribution to the Vero Beach airport fund. And there were rumors the Dodgers would train on the West Coast after the FOX Group purchased the franchise in 1998.

The Dodgers broke the major league's color barrier in 1947, but the success of future Hall of Famer Jackie Robinson didn't translate into harmony off the field in many Florida communities.

Former general manager Buzzie Bavasi tells a story about a time in 1952 when the Dodgers sensed some members of the city council might not want the ball club in town anymore. The original five-year lease was set to expire in 1953. Anticipating an important meeting the following Monday, Bavasi sent traveling secretary Lee Scott to the racetrack with a $40,000 check and instructions to bring back 20,000 $2 bills. Bavasi and the families of other Dodger officials stayed up late Wednesday and Thursday, stamping "BROOKLYN DODGERS" on the back of each bill. The players were told there was a problem in the kitchen and that they would have to eat in town over the weekend. The bills circulated into the local economy at restaurants, bars, and other businesses. Bavasi made his point and the crisis passed.

Dodgertown endured and blossomed and became arguably the most unique training facility in professional sports. So take a journey over the next 200 photographs and images into the world of Indian River County and reflect on a small town, a baseball team, and America.

ONE
The Beginning

You won't find a blueprint in terms of how to build the perfect spring training camp. Although Dodgertown in Vero Beach, Florida is the most famous among the baseball training facilities, its roots come from the various personalities and ambitions of those with the ball club and local community.

Hall of Fame executive Branch Rickey conceived of the farm system during his tenure with the St. Louis Cardinals in the late 1930s. Rickey joined the Dodgers in 1942 and kept his scouts busy looking for talent, despite a depleted supply of ballplayers due to World War II. Rickey knew the war wouldn't last forever.

Letters were written to more than 18,000 high school baseball coaches, asking for talent recommendations. Some 4,000 replies were received and tryout camps throughout the country were established. Dodger scouts inspected more than 2,000 youngsters and 400 were signed to contracts.

Other major league teams struggling to fill rosters following World War II turned to Rickey, who bankrolled the estimated $500,000 annual cost of his minor league operation by selling his excess ballplayers.

By 1946, Rickey unveiled his concept of a "farm factory." The Brooklyn Dodgers and their Triple-A Montreal Royals affiliate trained at Daytona Beach in 1946 while hundreds of minor league hopefuls assembled.

Meanwhile, the city of Vero Beach was looking for a tenant for the naval air station that the United States built during World War II. One of the city's most dynamic civic leaders and influential businessman would make the best of an otherwise bleak situation.

Local resident Bud Holman opened a Cadillac dealership in 1923 and became interested in aviation, thanks to his friendship with World War I hero Eddie Rickenbacker. In 1932, he convinced Eastern Airlines to make Vero Beach's airport a fueling stop. By 1935, Vero Beach was the smallest U.S. city to have direct airmail service.

During World War II, the airport and naval base in Vero Beach turned the tiny town into a military community. Holman didn't know much about baseball, but when the idea of inviting a major league franchise came along, Holman reportedly asked his wife as to which was the best team to invite. His wife replied, "the Dodgers," and Holman contacted Rickey at the Dodger offices in Brooklyn. Holman knew Rickey had 26 minor league teams and wanted a chance to prove that Vero Beach could host a full-scale training camp.

Rickey dispatched Buzzie Bavasi, the general manager of the Dodgers' Nashua, New Hampshire farm club. Because he didn't like to fly, the 31-year-old executive arrived by train. Bavasi was supposed to visit other potential sites at Ft. Piece and Stuart, but never had a chance. Holman's hospitality during a party on November 2, 1947, convinced Bavasi the facilities were already in place, especially because of Vero Beach's airport.

In a 1954 book collaborated with team photographer Barney Stein, *The Rhubarb Patch— The*

Story of the Modern Brooklyn Dodgers, broadcaster Red Barber recalled Rickey's fascination with the potential layout of a training camp. "Rickey dreamed about having everybody in one central place where he could see everything and everyone," Barber wrote. "Tremendous planning was involved, entailing constant staff work. Ballgames were being played on diamonds all day long. Instruction work kept the batting tees and cages busy, the sliding pits filled, etc. Rickey dreamed that by forced teaching, training, and close observation, a new player might be ready for the majors in a year's less time than otherwise.

"Food would be bought and served in volume, the barracks would house the hundreds, all would be living together in a world that was only baseball. And very important, possessing such a reservation, racial problems in Florida were neatly bypassed. This was merging the farm system into the factory."

In 1947, Jackie Robinson made his historic debut with the Dodgers, breaking the sport's color barrier and winning National League Rookie of the Year honors. Robinson trained for his rookie season without much fanfare as the Dodgers practiced in Havana, Cuba. One of the other big stories that spring was the decision by Commissioner Happy Chandler to suspend Dodger manager Leo Durocher for one year for "conduct detrimental to baseball," allegedly associating with known gamblers.

The Dodgers agreed to bring their minor league operation to Vero Beach in 1948, but primitive field conditions meant the major leaguers would play their exhibition games in the Dominican Republic and Miami. A fresh coat of paint was applied to the barracks, but extensive landscape work was required as the floor was covered with weeds. The minor leaguers played on fields near the Vero Beach airport and almost always carried a bat when walking because of snakes and other surprises in the area.

Rickey promised Vero Beach residents a taste of the major leagues in 1948 and the Dodgers faced their top farm club, the Montreal Royals, in two exhibition games on March 31 and April 1. During opening ceremonies in 1948, there was some question how Durocher would react to Chandler's presence. Durocher had returned to the Dodgers after his suspension, during which the Dodgers were managed by Clyde Sukeforth (four games) and Burt Shotton. There was a polite exchange of greetings on the field between Durocher and Chandler.

Upon arrival at Vero Beach from the Dominican Republic, teammates Ralph Branca and Pee Wee Reese walked into town and enjoyed a milkshake after dinner because milk was not readily available that spring at the Santo Domingo training camp.

In the first exhibition game in Vero Beach, more than 6,000 fans arrived and paid $1.25 for grandstand tickets. Florida governor Millard Caldwell threw out the ceremonial first pitch and Robinson's first-inning home run helped Brooklyn defeat Montreal, 5-4. The series became the cover image of the April 5 issue of a *Life* magazine, and hundreds of ballplayers posed for an overhead class photo. The four-page layout inside, trying to explain to the country this new type of camp and a baseball executive named Branch, was only the beginning of a most unique baseball story.

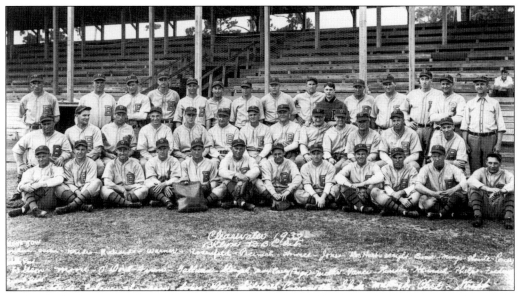

EARLY DAYS. From 1901 to 1948, the Brooklyn Dodgers spent spring training at various camps in North Carolina, South Carolina, Arkansas, Georgia, Louisiana, New York, Cuba, and the Dominican Republic. The Dodgers trained in Clearwater, Florida, from 1923 to 1932. Manager Max Carey's 1932 Dodgers finished third in the National League, nine games behind the pennant-winning Chicago Cubs.

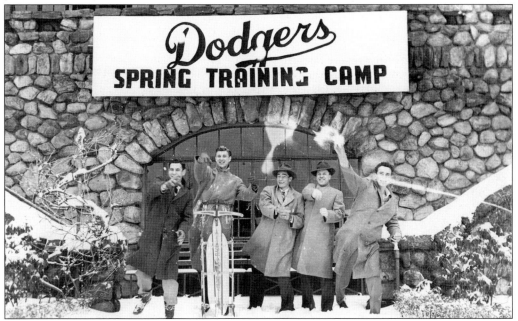

WAR RESTRICTIONS. With civilian train travel curtailed due to World War II, the Dodgers spent their springs in Bear Mountain, New York, from 1943 to 1945. The camp, located an hour's ride from Brooklyn, featured a snow-patched ski jump in the background of the baseball fields. Throwing snowballs are, from left to right, Tom Warren, Howie Schultz, Luis Olmo, Frank Drews, and Hal Gregg. During this time, the Dodgers also trained at West Point Academy's indoor field house, which the club was allowed to use during certain hours.

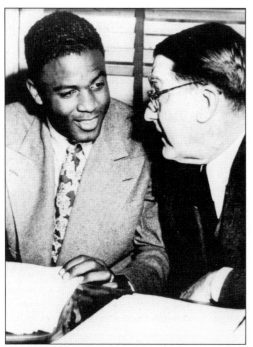

RICKEY AND ROBINSON. When Brooklyn Dodgers president Branch Rickey signed Jackie Robinson, breaking baseball's color barrier, he knew the ball club would need special accommodations for spring training, especially because of the South's segregation policies. Robinson spent his first spring with the Dodger organization in 1946, as Brooklyn and its Triple-A Montreal Royals affiliate worked out in Daytona Beach. The Dodgers trained in Havana, Cuba in 1947 and the Dominican Republic in 1948.

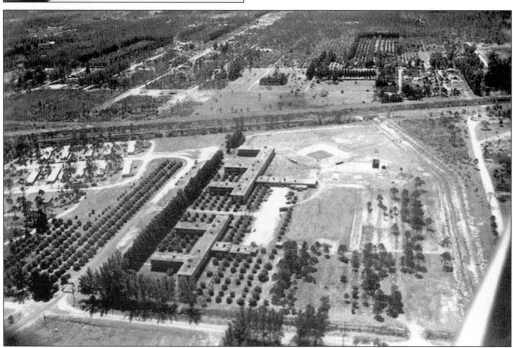

GRAND LAYOUT. From a military base during World War II to a virtual ghost town after the Navy's departure, Vero Beach held promise for Bud Holman and other local businessmen, who were convinced this land would be ideal for a major league baseball team's training facility. Holman flew to New York and sold the idea to Brooklyn Dodger manager Burt Shotton. Dodger president Branch Rickey, along with assistants Buzzie Bavasi and Spencer Harris, visited the Vero Beach site in November 1947.

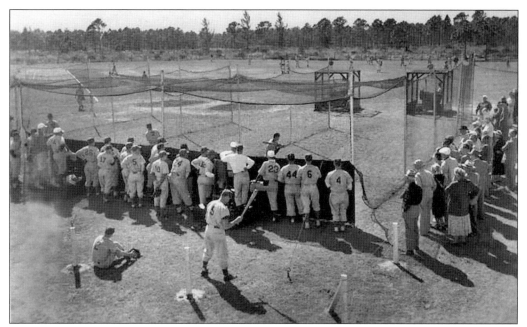

EQUIPMENT. How do you keep 600 players busy? In addition to dozens of batting cages, two mechanical pitchers, stationary batting tees, an electric-eye umpire that also measured the velocity of each pitch, the Dodgertown camp also featured a sliding pit and a straightaway cinder path with a track coach. The new Dodgertown camp made the cover of Life magazine on April 5, 1948.

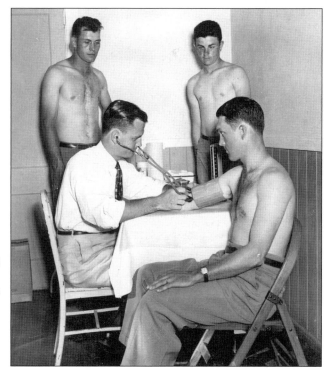

MEDICAL EXAM. Pitcher Carl Erskine receives a physical upon reporting to the Dodgers for spring training. The Anderson, Indiana native played for the Dodgers from 1948 to 1959. Erskine pitched the first game in Holman Stadium history in 1953 and won the Dodgers' first game played in Los Angeles in 1958.

NAVAL BARRACKS. Early in the morning, camp mailman and night watchman Herman Levy began the new day with a "hit-the-deck" whistle. Temporary barracks used to house servicemen were built at the Vero Beach naval air station during World War II and eventually became home to more than 600 Dodger players, coaches, front office staff, and members of the press.

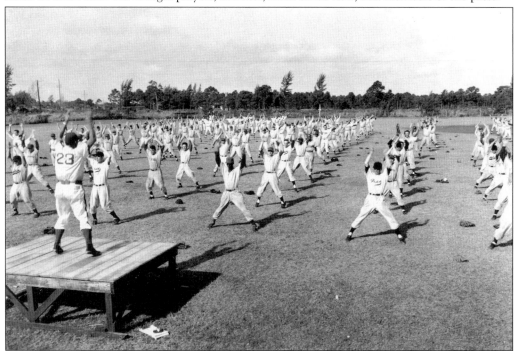

JUMPING JACKS. Future Dodger general manager Al Campanis leads the Dodger players in morning exercises. Campanis, an infielder during his playing career, was scouting director in 1954 when he wrote *The Dodger Way to Play Baseball*, an instructional book featuring drawings by New York artist Tex Blaisdell. The book featured spring training photos from Dodgertown on the dust jacket.

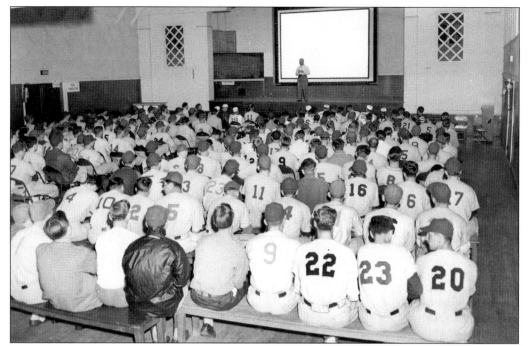

BASEBALL LECTURES. Dodger president Branch Rickey wanted his Dodger campers to receive the best instruction from his expert staff, which at various times could include Fresco Thompson, George Sisler, Paul Waner, Andy High, Wid Matthews, Pepper Martin, Ray Blades, Clay Bryant, Greg Mulleavy, John Carey, and Walter Alston. Topics covered batting, pitching, signals, bunting, base running, cut-offs and relays, and overall fundamentals.

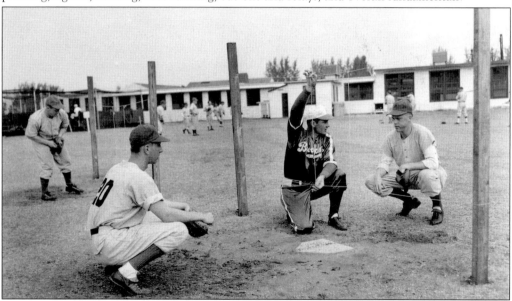

STRINGS AREA. By constructing a makeshift strike zone using strings attached to poles, up to six Dodger pitchers at a time could simulate better targets when practicing their control. The strings area at Dodgertown remains intact, located just outside the porch area of the lounge in front of main Field No. 1.

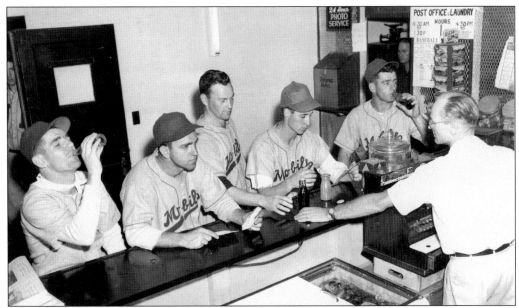

DODGER CANTEEN. With few automobiles on site in the early 1950s (they were actually discouraged by management in a spring training preparation letter), players relied on the many amenities offered at Dodgertown, including laundry service, a post office, barbershop, and canteen. Between morning and afternoon sessions, the players lunched in their uniforms where a sign in the cafeteria read, "Take all you want but eat all you take."

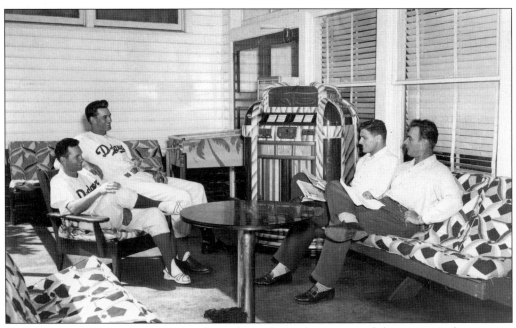

RECREATION. The Dodgers tried to keep their players busy, even if they weren't focusing on baseball. The early years in Dodgertown included a jukebox, pool tables, shuffleboard, ping-pong tables, horseshoe-pitching court, croquet courts, pinball machines, and movies three times a week.

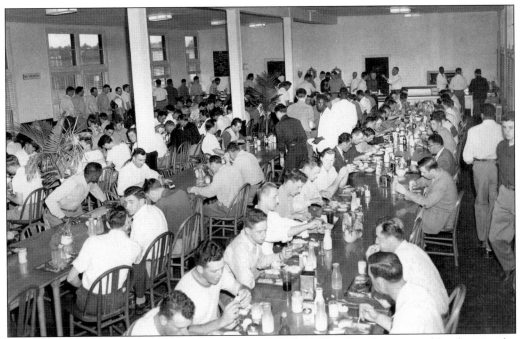

THE DINING ROOM. After a long day of baseball drills, the players could relax in the Dodgertown dining room. This cafeteria setup meant that team officials waited in line with players from the various levels, adding to the "family" atmosphere of the camp.

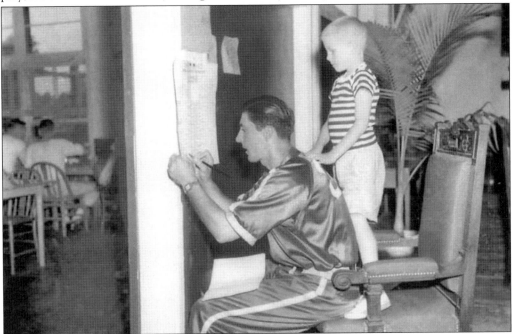

PLANNING AHEAD. Dodger scouting director Al Campanis posts the next day's assignments on a board just outside of the dining room. Watching Campanis is Dodger president Branch Rickey's grandson, Branch Rickey III, who would become the president of the Pacific Coast League.

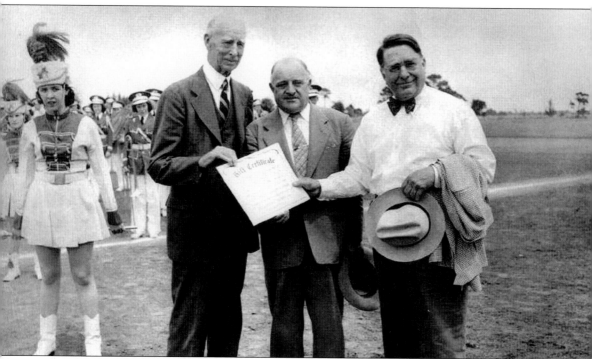

SNEAK PREVIEW. Although the Dodger minor leaguers were in Vero Beach in 1948, the major leaguers arrived from Santo Domingo on their way to Brooklyn for exhibitions with their Montreal farm team. Dignitaries attending the first game included Florida governor Millard Caldwell and Vero Beach mayor Merrill Barber. Local radio station WIRA broadcast the festivities, and local businesses Indian River Citrus Bank, Wodtke's, Osceola Pharmacy, Rowland Miller Chevrolet, and the Ft. Pierce Merchants Association sponsored the games. One year later, Dodger president Branch Rickey poses with Philadelphia Athletics manager Connie Mack prior to the first Vero Beach exhibition game featuring two major league teams.

TWO
The 1950s

Following the 1950 season, Walter O'Malley replaced Branch Rickey as team president; however, many of the regimens designed by Rickey's staff would become staples of the Dodger training routine over the next few decades. Vice President Fresco Thompson remained in place as camp field supervisor while his assistant, scout Al Campanis, authored the 1954 instructional manual, *The Dodger Way to Play Baseball*. O'Malley focused on the business end of the Dodgers and left player personnel decisions to his general manager, Buzzie Bavasi.

O'Malley's relationship with New York-based architect Emil Praeger stretched back to 1946 when, as club vice president, O'Malley inquired about Praeger's designs for a potential new ballpark in Brooklyn to replace aging Ebbets Field. With the Dodgers' original agreement with Vero Beach about to expire in 1953, O'Malley decided to build a permanent home at Dodgertown. In January 1952, the Vero Beach City Council agreed to give the Dodgers a 21-year lease at $1 per year.

O'Malley and Praeger began work on an intimate-styled stadium with unobstructed field views at reasonable costs. The stadium was built by excavating 20,000 cubic yards of sand, marl, and muck. The excavation area was turned into a two-acre fishing lake and stocked by the United States Wildlife Service. The fill formed into mounds, which were compacted and rolled, then four-inch reinforced concrete was poured over the mounds to make the stands.

O'Malley named the ballpark in Bud Holman's honor because of his dedication to the Vero Beach community and continued interest in the development of Dodgertown. "Holman Stadium" was officially dedicated on March 11, 1953. An overflow crowd of 5,532 watched the Brooklyn Dodgers defeat the Philadelphia Athletics, 4-2.

There were different admission prices for the 1953 Dodger exhibition games — box seats ($3), reserve seats ($2), and general admission (50¢). The tickets were reduced by 50 percent for minor league games played at Holman Stadium. In the first season, patrons could purchase Dodger tickets in town at the Vero Beach Cadillac Company, McClure Drug Store, and Ocean Grill.

The Dodger major leaguers played four games at Holman Stadium in 1953. Their headlined opponents on the printed spring exhibition schedule and ticket order forms were the Philadelphia Athletics, Washington Senators, Montreal Royals, and "Boston" Braves (the schedule required a revision when the franchise announced its transfer on March 18).

The Dodgers were en route to the National League pennant in 1953 when O'Malley sent a September 2 memo to the Brooklyn clubhouse. Despite 22 games left in the regular season and the playoffs on the horizon, O'Malley was already looking ahead to the following spring training. He sent blueprints of the proposed nine-hole golf course at Dodgertown and wanted to solicit opinions.

In the memo to Erskine, O'Malley wrote, "Be good enough to post this pitch and putt golf layout on the bulletin board and let me have it back after tomorrow's game with suggestions from any of our golf playing members. In other words, as long as we are going to do the job it

19

might just as well have the benefits of criticism. You can tell Carl Furillo that this will not interfere with the fishing as the bass in the pond are all educated to digest golf balls (furnished at the player's expense, of course)."

Erskine hand-wrote his reply on the memo:

> Dear Mr. O'Malley,
> The players have examined the golf layout and are very enthusiastic about it. The only suggestion anyone seemed to have was on hole #6. It seems to be the most hazardous and since most of us are hackers and wives will also be playing, it is suggested that a screen or backstop of some kind be put behind the green. Reese wishes to announce at this early date that anyone catching a bass with a Max-fly in it—the ball belongs to him. Thanks for sending down the plans.

With a fishing lake and golf course in place, the Dodgers looked to expand the use of the facility beyond spring training. In February 1954, the Dodgers hosted a "baseball school" for amateur baseball officials prior to spring training. The teaching staff included Dodgers Pee Wee Reese and Carl Erskine, National League umpire Larry Goetz, Long Island University baseball coach Buck Lai, Dodger team physician Dr. Eugene Zorn, and Dodger scout Arthur Dede. The Dodgers also launched a summer camp for boys, utilizing the same equipment and amenities offered to the Brooklyn major and minor league players during spring training.

The Brooklyn Dodgers won their only World Series in 1955, defeating the New York Yankees in a thrilling seven-game classic as left-hander Johnny Podres fired a 2-0 shutout in the final game at Yankee Stadium.

Although Brooklyn repeated as National League champions in 1956, the rumblings and speculation whether the Dodgers would leave Ebbets Field soon became a topic of public debate. O'Malley's negotiations with New York city officials for a proposed sports complex bogged down, and Los Angeles entered the picture when local government leaders in search of a major league franchise contacted O'Malley following the 1956 World Series.

The tranquility of Vero Beach served as an ideal setting for the otherwise turbulent spring of 1957, when O'Malley in late January hired Emmett Kelly, renowned clown of the Ringling Brothers circus, "to ease tensions at Ebbets Field." Bringing to life the "Dodger bum" character originated by New York newspaper cartoonist Willard Mullin, Kelly's trademark was a tattered suit with a "soulful forlorn look that has brought guffaws from millions." Kelly joined the club in Vero Beach and performed for the Dodgers' other minor league clubs.

Shortly after the 1957 season, the Dodgers announced they were leaving Brooklyn and moving to Los Angeles. It was a sad time for New York baseball fans, as the storied Giants also departed the Polo Grounds and maintained the rivalry with the Dodgers by moving to San Francisco on the West Coast. The next few years would present even more challenges to O'Malley, as lengthy court battles delayed his plans to build a new ballpark in Los Angeles.

But with Holman Stadium in place and Dodgertown running on all cylinders, the Dodgers knew they could always count on one calm port in the storm of uncertainty toward the end of the decade. The Vero Beach camp gave the Dodgers a solid foundation for whatever lay ahead.

NEW DECADE. As time marches on, teammates Joe Hatten (19) and Bobby Morgan (50) become a makeshift calendar for photographers. "Lefty Joe" pitched for Brooklyn from 1946 to 1951 and was on the mound when outfielder Al Gionfriddo robbed the Yankees' Joe DiMaggio of a home run in the 1947 World Series. Morgan, an infielder, spent parts of three seasons with the Dodgers from 1950 to 1953.

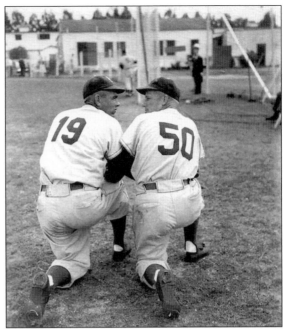

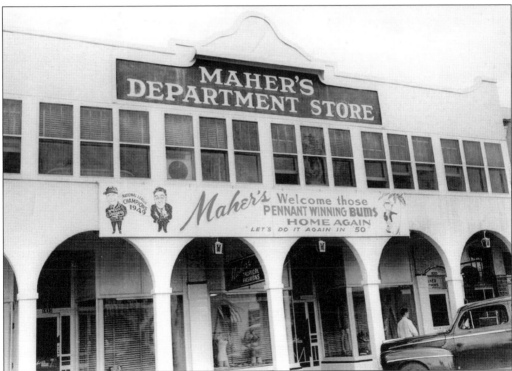

COMMUNITY SUPPORT. A sign on Maher's Department Store features a cartoon of Dodger manager Burt Shotton and team president Branch Rickey flanking a "National League Champions 1949" banner. The main sign reads: "Maher's Welcome those PENNANT WINNING BUMS HOME AGAIN—LET'S DO IT AGAIN IN '50." The Dodgers finished the regular season in first place in 1950, but lost a playoff game to the Philadelphia Phillies.

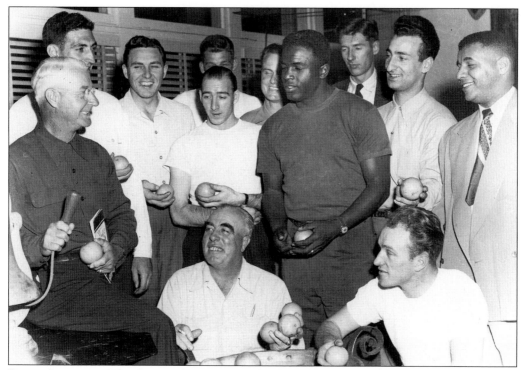

BURT SHOTTON. The former St. Louis Cardinals outfielder managed the Dodgers in two tenures from 1947 to 1950. He took over in April 1947 after manager Leo Durocher's one-year suspension and Clyde Sukeforth's four-game tenure, and returned in mid-1948 when Durocher was fired. Shotton didn't wear a uniform, opting instead for street clothes, a Brooklyn cap, and a warm-up jacket. Along with assembled players is Vero Beach businessman Bud Holman, holding citrus from the Indian River County.

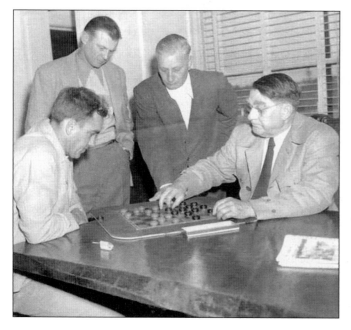

CHECKMATE. Although seen in his office playing checkers, Branch Rickey's baseball strategy was more on the level of a chess match. "The Mahatma" moved the Dodgers to the top of the National League standings, thanks to a bountiful farm system and other key player transactions. Rickey began his professional career as a catcher in the St. Louis Browns organization and later developed the idea of a "farm system" during his tenure with the St. Louis Cardinals.

WALTER O'MALLEY. The New York native succeeded Branch Rickey as Dodger president on October 26, 1950 and posed (center) the following spring with vice president Fresco Thompson (left) and Dodgertown camp director Spencer Harris (right). The O'Malley family would own the Dodgers for 48 years until 1998. The investment and development by Walter and Peter O'Malley made Dodgertown a state-of-the-art training base.

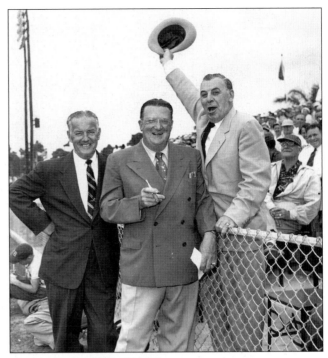

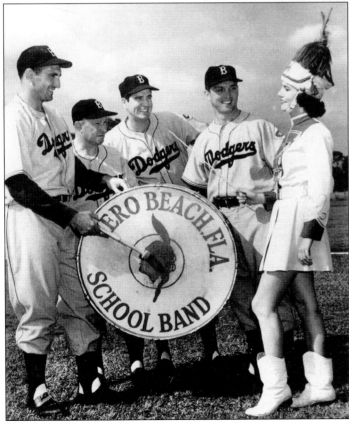

STRIKE UP THE BAND. Pitcher Ralph Branca, manager Charlie Dressen, pitcher Clyde King, and pitcher Carl Erskine meet Vero Beach School drum majorette Jean Law on the first day of spring training in 1952. After building a 13-game lead in 1951, the Dodgers finished the season tied for first place. Brooklyn lost a three-game playoff series to the New York Giants on Bobby Thomson's ninth-inning home run at the Polo Grounds on October 3.

23

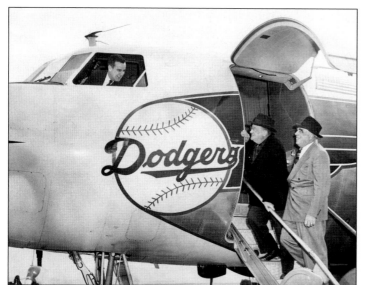

DODGER PLANE. Harry R. "Bump" Holman, the son of Vero Beach businessman Bud Holman (far right), was the captain of three types of Dodger team planes in the 1950s and 1960s: a Convair 440, DC-3, a DC-6B, and an Electra. The Holmans flank Dodger president Walter O'Malley, whose major league team began flying on the team plane during spring training in 1951.

AIRPORT TRAFFIC. Vero Beach community leaders explored the possibility of an airport in 1928. Flight traffic began one year later and in 1932, Eastern Airlines decided to make Vero Beach a stopping point for air passenger service to Miami, New York, and New Orleans. Vero Beach was also selected as an official airmail pickup spot in 1935, the smallest city in the United States to have direct airmail service.

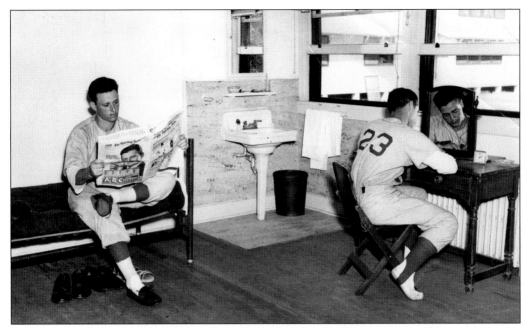

ROOMMATES. These Dodger players share a room inside the former naval air station barracks. Although the accommodations were less than ideal, the housing actually brought the Dodgers closer together as an organization and set the tone for the upcoming season. Those who battled a cold evening could always look forward to a fresh pot of coffee in the lobby and teammates ready to compare notes about living in the barracks.

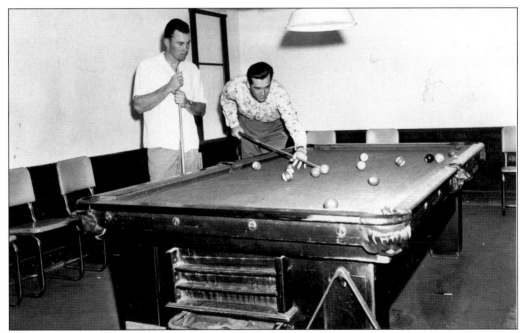

CORNER POCKET. These players enjoy a game of pool in the recreation room of the old barracks. The current lounge at Dodgertown includes two pool tables in the main room and a ping-pong table on an enclosed porch overlooking the pitching strings area and Field No. 1.

May 5, 1952.

Wid C. Matthews, Personnel Director,
Chicago Cubs,
Wrigley Field,
Chicago, Ill.

My dear Wid:

　　　Fresco, Buzzie and I have been going over a map of our property
at Vero Beach and I was reminded of an informal conversation you and
I had sometime ago. I now believe it would be possible to plan for
the development of the Dodger camp to the west of fields 1 and 2, as
we have brought that additional land under our lease. This means that
we could release diamonds 3 and 4 plus the recreation building to
another organization.

　　　Capt. Praeger, who was Chief of the Bureau of Design for the
Navy during the War, is getting the plans on the recreation building
and he believes it would lend itself to simple alterations to permit
the housing of 100 men. There are several barracks between the recreation
building and diamonds 3 and 4 which could be repaired for occupancy.
They are now in the condition that our buildings were in, as you can
recall, when we took over 5 years ago.

　　　We believe that two organizations could train in the same town
if we had separate fields and eating and sleeping quarters. We
would not be too much concerned about the problem of fraternizing.

　　　I have in mind we would give you a 21 year sub-lease or we might
arrange to surrender those premises and have the new lease made out
directly to your organization. We would charge you a flat sum of money
for the fields already built as we would have to build their replacements.
You could figure that cost as rental. You know from the general location
that there is ample room for you to expand, should you wish.

　　　　　　Sincerely,

WFO'M:EM
　　　　　　　　　　Walter F. O'Malley,
　　　　　　　　　　President.

DodgerCubTown? This May 5, 1952, letter from Dodger president Walter O'Malley to Chicago Cubs personnel director Wid Matthews outlines a proposal to divide the Vero Beach complex. The Cubs had the choice of a 21-year sublease or a direct lease from the city if the Dodgers surrendered control of the land to the west of Fields Nos. 1 and 2. The Cubs, who trained on Catalina Island off the California coast from 1921 to 1951 (except for three years in French Lick, Indiana during World War II), opted to remain in their new spring headquarters in Mesa, Arizona.

STADIUM PLAN. In 1946, Dodger vice president Walter O'Malley wrote New York architect Emil Praeger about ideas for a proposed new ballpark in Brooklyn. While O'Malley and Praeger never had a chance to construct a sports complex to replace an aging Ebbets Field, the pair conceived the plans for Holman Stadium in Vero Beach. Many of the construction techniques were later used when O'Malley and Praeger built Dodger Stadium in Los Angeles.

STADIUM MODEL. To honor her late husband, former Dodger stockholder John L. Smith, Mae Smith donated 50 Royal Palm trees, which dotted the outfield at Holman Stadium when it opened in 1953. John Smith, a chemist, was president of Charles Pfizer Company. He often took the players and writers out sailing during spring training.

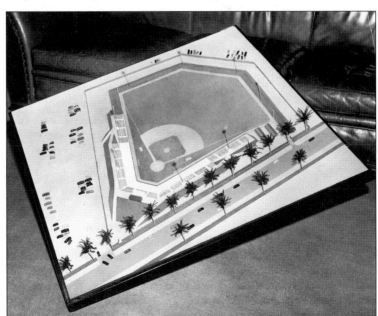

MEMBER OF THE AUDIT BUREAU OF CIRCULATIONS

Vero Beach
PRESS-JOURNAL
INDIAN RIVER COUNTY

FIRST WINNER OF JOHN LOCHNER TROPHY FOR BEST WEEKLY NEWSPAPER IN FLORIDA

J. J. SCHUMANN, PUBLISHER

VERO BEACH · FLORIDA

November 22, 1952.

Mr. Walter F. O'Malley, President,

 Brooklyn Baseball Club,

 Brooklyn, N. Y.

Dear Mr. O'Malley,

 I am glad to report that Mr. Merrill Barber has agreed to act as chairman of the dedication activities in connection with the opening of the new "Bud Holman Stadium." Mr. Barber is president of the local bank, the "Indian River Citrus Bank," and it might be well for you to drop him a line confirming his selection for this place. He is very much interested in base ball, and enjoys the kind of activity connected with the dedication ceremony, is a good master of ceremonies, and is the logical man for the job. I will be glad to cooperate with him in every way.

 Sincerely yours,

 J J Schumann

LLC

 J. J. Schumann, Publisher.

BIG NEWS. This letter from *Vero Beach Press Journal* publisher John Schumann to Walter O'Malley praises the Dodger president for naming the new Dodger stadium after local businessman Bud Holman. The first game at Holman Stadium was played on March 11, 1953, and an overflow crowd of 5,532 attended and watched pitcher Carl Erskine defeat the Philadelphia Athletics, 4–2.

FIRST PROGRAM. Distinguished guests at the Holman Stadium opener included baseball commissioner Ford C. Frick, National League president Warren Giles, and American League president William Harridge. Vero Beach mayor Cola B. Streetman extended greetings and Eastern Airlines vice president Jack Frost spoke on behalf of Captain Eddie Rickenbacker. The pre-game festivities were carried live on the radio.

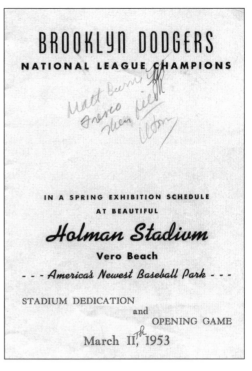

BROOKLYN DODGERS
NATIONAL LEAGUE CHAMPIONS

IN A SPRING EXHIBITION SCHEDULE
AT BEAUTIFUL

Holman Stadium

Vero Beach

- - - *America's Newest Baseball Park* - - -

STADIUM DEDICATION
and
OPENING GAME
March 11th, 1953

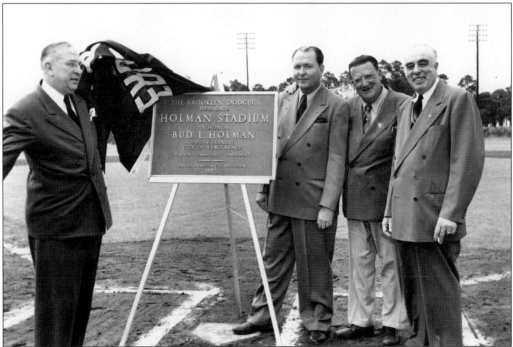

DEDICATION. Dodger President Walter O'Malley, Vero Beach businessman Bud Holman, and Merrill P. Barber, president of the Indian River County Citrus Bank and emcee for the ballpark ceremonies, celebrate the opening of the new Holman Stadium on March 11, 1953. The plaque today is located on the third-base side of the press box façade behind home plate.

SPRING FLOWERS. Terry O'Malley and Ann Thompson, daughters of Dodger executives, enjoy the Florida sun at Holman Stadium. Terry, who married Southern California investment banker Roland Seidler in 1958, later became co-owner of the franchise with her brother Peter. Thompson's father, Fresco, was the longtime minor league vice president whose 1964 autobiography was titled, *Every Diamond Doesn't Sparkle.*

GOLF OUTING. The wives of Dodger executives enjoy a round of golf on the new nine-hole "pitch and putt" course at Dodgertown in 1954. From left to right are Elizabeth Hickey, Edna Praeger, Peg Thompson, Mae Smith, Kay O'Malley, and Lela Alston.

30

St. Patrick's Day. Guests at Dodgertown knew to circle March 17 on their calendars because the annual party was the biggest event of the camp. In this 1953 photo, Dodger families celebrate; from left to right are Evit and Buzzie Bavasi, Kay and Walter O'Malley, Peg and Fresco Thompson.

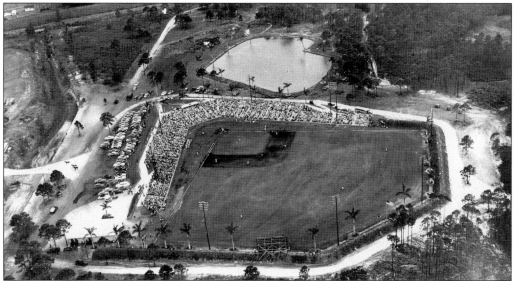

Valentine. A heart-shaped lake was designed by Walter O'Malley as a salute to his wife, Kay. The fishing lake adjacent to Holman Stadium would become a popular site for both players and executives.

6:45 Meeting of the Polar Bear Club for Ocean Swim before Breakfast.

7:30 RISE AND SHINE 7:30 - 8:00 SICK CALL
7:55 COLORS 8:00 - 8:30 BREAKAST
8:30 - 9:00 Room clean-up and Inspection.
 BROOKLYN and MONTREAL — Hand in personal laundry at Supply Room.
 ST. PAUL and FORT WORTH — Pick up clean towels.
 MOBILE and ELMIRA—Pick up clean sheets and pillow cases.
8:30 - 11:30 BROOKLYN—Intra-squad game at Holman Stadium.
 MONTREAL—Basketball in the Auditorium.
 ST. PAUL—Riflery at the Range.
 FORT WORTH—Batting cages, one hour—Pitching strings, 1 hour.
 MOBILE—Track, one hour—Tennis, one hour.
 ELMIRA—Intra-squad game—Field No. 1.
11:30 - 12:30 SWIM in Lake or Pool 12:30 - 1:00 SICK CALL
12:30 - 1:15 LUNCH 1:15 - 1:30 CANTEEN
1:30 - 2:30 REST HOUR—Today is Write-a-Letter-Home-Day. This letter is your ticket to Dinner. Camp Barber will be available during Rest Hour.
2:30 - 4:30 The following activities will be available:
 Ocean Swimming, Life Saving Instruction—Pool, Boating and Canoeing—Lake, Horseback Riding, Trip to McKee Jungle Gardens, Fishing in the Indian River, Outdoor Basketball.
 BASEBALL:
 Pitching instruction at the String area, Infielders clinic on Field No. 2, Batting Cages.
4:30 - 5:30 SWIM in Lake or Pool 5:55 COLORS
6:00 - 6:30 DINNER 6:30 - 7:30 SICK CALL
7:00 - 7:30 The following activities will be available:
 Badminton, Volley Ball, La Crosse, Golf, Touch Football, Batting Cages, Bamboo Shop, Ping Pong, Horseshoes, Croquet.
7:30 - 9:30 BASEBALL GAME under the lights at Holman Stadium. MONTREAL vs. ST. PAUL. Both teams report in uniform at the Stadium at 7:15 for short infield drill and the game will begin shortly after. No inning will start after 9:30. Since this game will not be televised, everyone will want to be at the Stadium at 7:30. No admission—plenty of choice seats available.
9:30 CANTEEN 10:00 LIGHTS OUT

BOYS CAMP ACTIVITIES. This schedule outlines a day in the life of a summer camper at Dodgertown. The two-month tuition, which included board, lodging, and laundry service, was $600 in 1954. The campers were divided into groups named after the Dodger minor league affiliates in Montreal, St. Paul, Fort Worth, Mobile, and Elmira.

IRON MIKE. This pitching machine was used both in the early days at Dodgertown and at the Boys Summer Camp. The boys also were schooled in basketball, football, tennis, badminton, volleyball, track and field, swimming, fishing, archery, and many other sports.

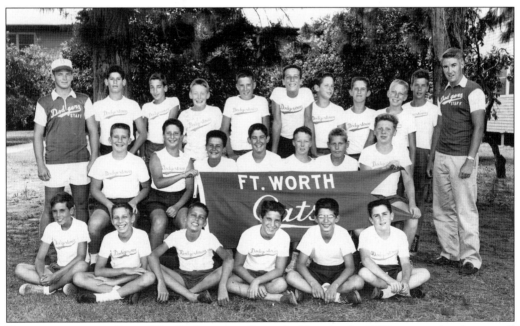

DODGERTOWN FOR BOYS. The Dodgertown Camp for Boys in the 1950s was under the overall supervision of Edgar Allen, the second "Mayor of Dodgertown" following Spencer Harris (1948–1953). On the far right is Peter O'Malley, camp counselor and future president of the ballclub.

NEW MANAGER. When Charlie Dressen requested a multi-year contract following the 1953 season, the Dodgers replaced him with Walter Alston, a veteran manager in the Dodger minor league organization. Alston's first Brooklyn coaching staff in 1954 were, from left to right, Billy Herman, Jake Pitler, and pitching coach Ted Lyons.

BONUS BABY. Shortstop Pee Wee Reese and his wife, Dottie, hold newborn Mark Allen Reese at Dodgertown. General manager Buzzie Bavasi offers a post-dated contract to the baby, who would later direct the film, *The Boys of Winter*, which won the Grand Jury Prize for best documentary at the 2001 New York International Independent Film Festival.

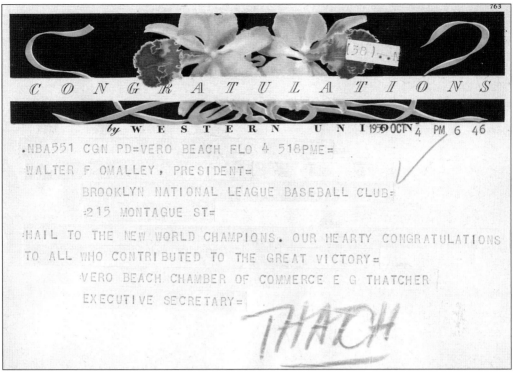

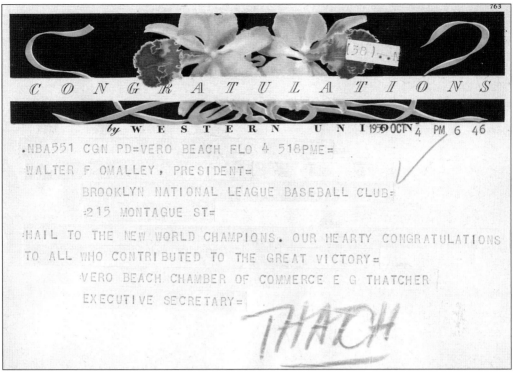

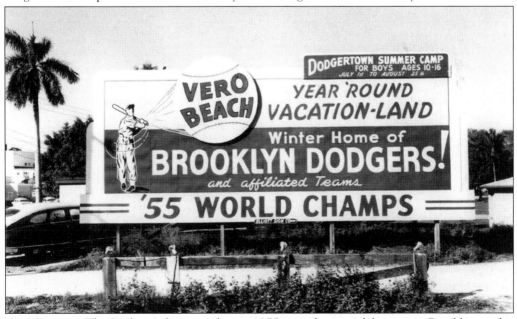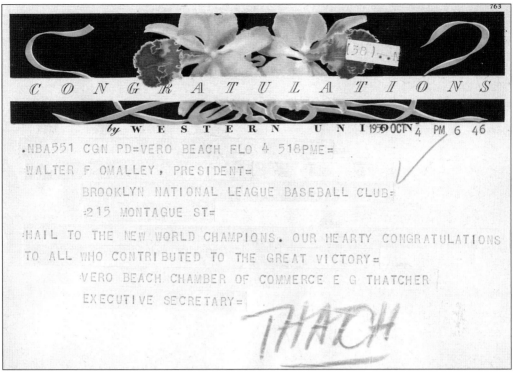

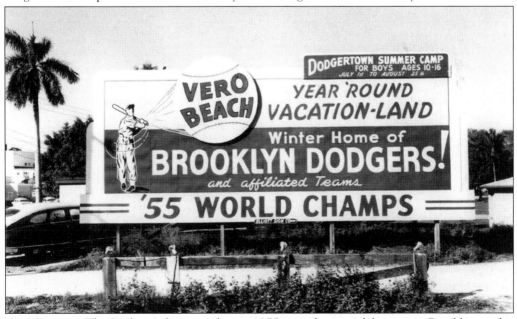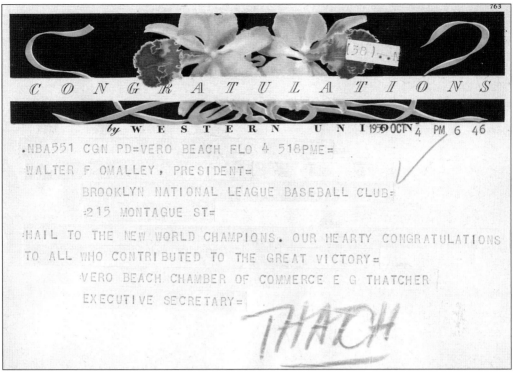

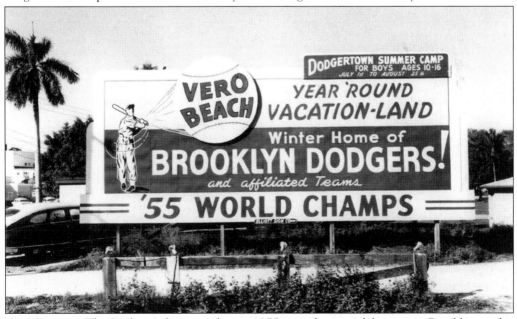

FINALLY. Hours after the Brooklyn Dodgers clinched their first championship on October 4, 1955, Vero Beach Chamber of Commerce Executive Secretary E.G. Thatcher wired a congratulatory telegram to team president Walter O'Malley at the Dodgers' offices in Brooklyn.

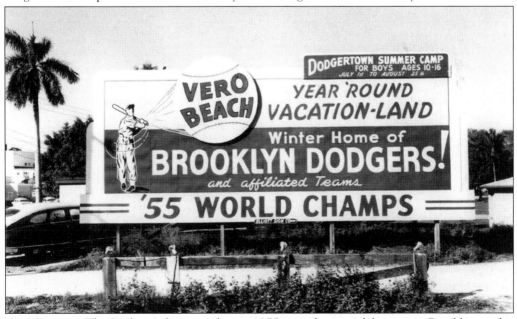

THE CHAMPS. The Dodgers' championship in 1955 caused great celebration in Brooklyn, and it provided a chance to alter the advertising campaign in Vero Beach. In addition to touting the championship, this billboard also pitches the Dodgertown Boys Summer Camp.

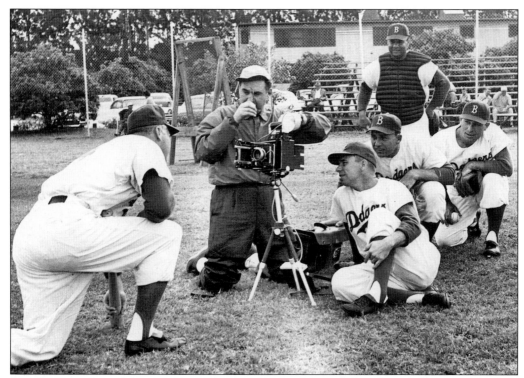

SAY CHEESE. One of the annual rituals of spring training includes taking ballplayer photos for publicity purposes. In 1957, Dodger photographer Herb Scharfman poses outfielder Duke Snider to the amusement of his teammates, Pee Wee Reese, Gil Hodges, Roy Campanella, and Carl Furillo.

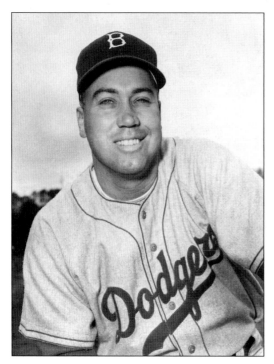

FINISHED PRODUCT. Duke Snider had every reason to smile during the spring of 1957. In the prime of his Hall of Fame career, Snider set a Brooklyn franchise record with 43 home runs in 1956. Snider would establish the franchise career mark with 389 home runs from 1947 to 1962.

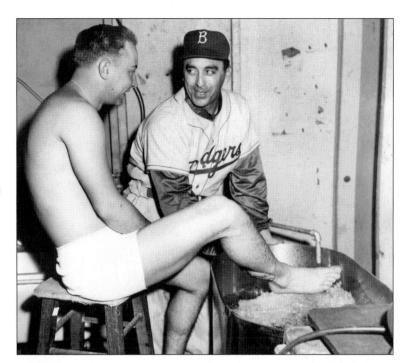

WATERWORKS. Johnny Podres soaks his feet in a whirlpool bath with the aid of fellow pitcher Sal Maglie during spring training in 1957. Podres beat the Yankees in Game 7 of the 1955 World Series, but missed the 1956 season to serve in the Navy. The Dodgers acquired Maglie during the summer of 1956 and the one-time New York Giants star went 13-5, including a no-hitter.

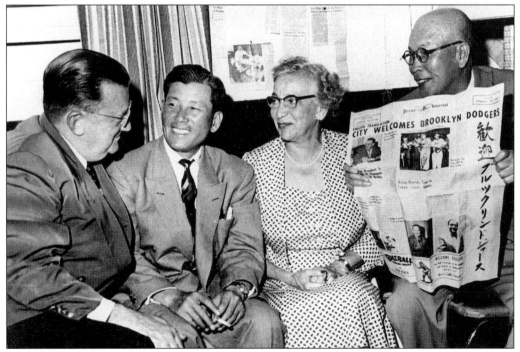

JAPAN EXCHANGE. After the 1956 World Series, the Brooklyn Dodgers embarked on a 20-game goodwill exhibition tour of Japan. In the spring of 1957, team president Walter O'Malley welcomed Shigeru Mizuhara, manager of the Tokyo Giants, and Sotaro Suzuki, sportswriter and consultant to Matsutaro Shoriki and the Giants. Also pictured is Mrs. Mae Smith, whose husband, John, was a part-owner of the Dodgers until his death in 1950.

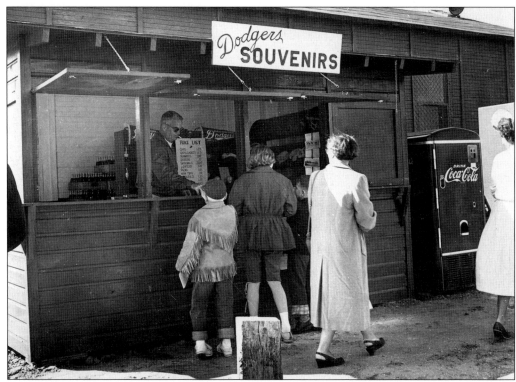

SOUVENIRS. There were plenty of choices for this youngster visiting the Dodgertown souvenir stand in 1957. Among the items for sale included caps ($1.25), pennants ($1), rosters (10¢), baseballs ($3), and pens ($1). Adults could also choose lighters ($3), ashtrays (50¢), and neckties ($1.25).

EMOTIONS ON SKIN. Infielders Pee Wee Reese and Don Zimmer watch as three fans campaign to "Keep the Dodgers in Brooklyn" during the debate in March 1957 over whether the Dodgers would move to California.

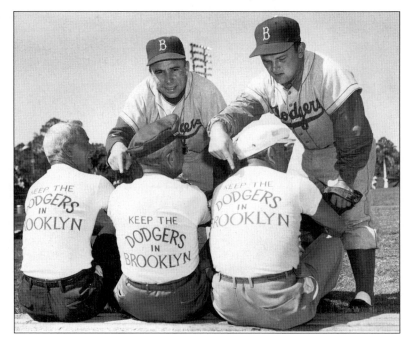

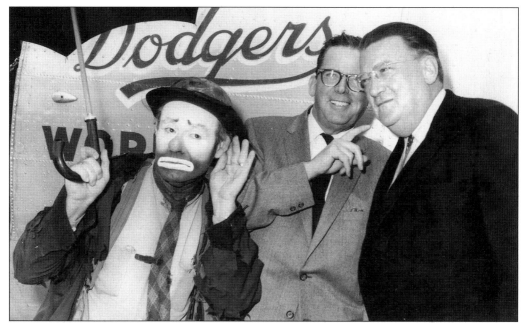

CLOWNING AROUND. With the uncertainty surrounding the Dodgers' rumored move to Los Angeles, team president Walter O'Malley hired famed circus clown Emmett Kelly to perform at Dodgertown, Ebbets Field, and at various Dodger minor league affiliates during the 1957 season. Kelly "listens" to a conversation between O'Malley and Los Angeles mayor Norris Poulson, who was in town with Southern California officials.

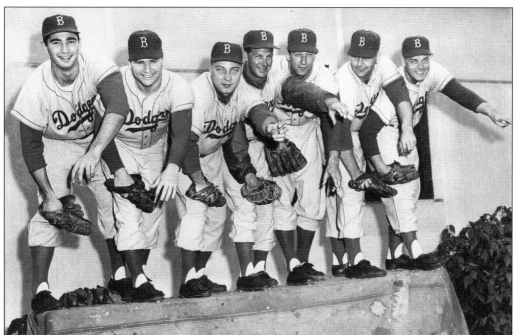

BEST ARM FORWARD. Among the hopeful pitchers in the 1957 camp were these seven left-handers, from left to right: Sandy Koufax, Marty Stabiner, Johnny Podres, Karl Spooner, Fred Kipp, Chuck Templeton, and Kenny Lehman.

WESTWARD HO! Although the Dodgers returned to Vero Beach for spring training in 1958, their final destination would be more than 3,000 miles away in Southern California. The Dodgers would play their home games on a makeshift baseball field at the Los Angeles Coliseum, which was originally designed for football and track events.

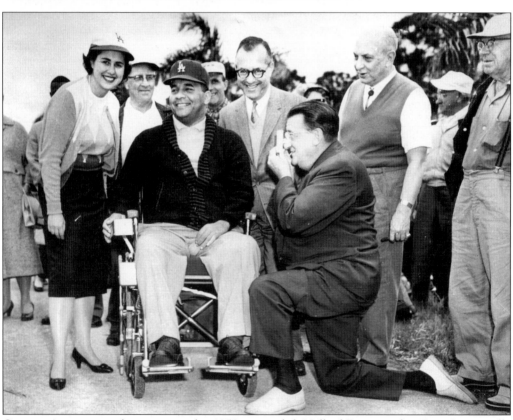

CAMPY. An auto accident prior to the 1958 season left Hall of Fame catcher Roy Campanella paralyzed and fighting for his life in a New York hospital when the Dodgers reported for spring training. Campanella eventually returned as a camp instructor and remained a fixture at Dodgertown until his death at age 71 in 1993. In this 1959 photo, Walter O'Malley aims his camera while Los Angeles councilwoman Rosalind Wyman and others tout Campanella's arrival.

THREE
The 1960s

When the Dodgers reported to spring training in 1960, they arrived as the reigning World Champions. Posting perhaps the most unlikely title in franchise history, the Dodgers had rebounded from a seventh-place showing at 71-83 in their first season on the West Coast and rallied in 1959. They finished tied with the Milwaukee Braves after the regular season with an 88-66 record and defeated the Braves in a playoff and advanced to the World Series. Their opponent would be the Chicago "Go-Go" White Sox, only the third American League team other than the New York Yankees to appear in the Fall Classic since 1947. Reliever Larry Sherry won Series MVP honors with two victories and two saves, reserve Chuck Essegian set a record with two pinch-hit home runs as Los Angeles won the Series in six games.

It would be the last hurrah for many of the old Brooklyn Dodgers, including reliever Clem Labine, first baseman Gil Hodges, and outfielder Carl Furillo. Pitcher Carl Erskine didn't make it through the 1959 season, opting to retire in early June because of arm troubles, which opened the door for relief pitcher Roger Craig.

As the Dodgers settled on the West Coast in 1958, a public referendum and lengthy court battles delayed the construction of a new ballpark, delaying the opening of the 56,000-seat Dodger Stadium until 1962.

But the Dodgers also faced challenges in Florida when Vero Beach city officials in 1961 considered rescinding the lease. At a city council meeting, officials emphasized that Vero Beach wanted to keep the Dodgers, but claimed the 21-year lease was a violation of a city charter in 1951 that had set a 20-year limit on any lease of city property. There was also the question whether the Federal Aviation Administration had jurisdiction over any lease for the property by the city for any use other than aviation.

Dodgertown director Peter O'Malley's negotiations with the city and the FAA eventually led to the purchase of the Vero Beach property by the Dodgers. In September 1964, the Dodgers agreed to pay $133,087.50 for 110.4 acres of airport land, buildings, and improvements. Over the years, the Dodgers purchased more property and expanded, including the construction of an 18-hole golf course in 1965.

On the field, the Dodgers were enjoying the height of a dynasty, led by future Hall of Fame pitchers Sandy Koufax and Don Drysdale. The Dodgers lost a best-of-three playoff to San Francisco in 1962, blowing a two-run lead in the ninth inning of the final game at Dodger Stadium. But the Dodgers roared back in 1963 and swept the Yankees in four straight games in the World Series. After an off year in 1964, the Dodgers posted consecutive pennants, including a thrilling seven-game classic over Minnesota in the 1965 World Series.

Dodgertown had two directors during the first 12 years of the camp, Spencer Harris (1948–1953) and Edgar Allen (1954–1959). The 1960s brought Leon Hamilton (1960–1961), Chuck Walmsley (1961), Peter O'Malley (1962–1965), John Stanfill (1965), and Dick Bird (1965–1974).

On June 1, 1964, Bud Holman died at his Blue Cypress ranch at age 63. He became ill a few

months after returning from the Dodgers' spring training trip to Mexico City. Pallbearers at his funeral were Grant Donaldson, Merrill Barber, Clark Rice, Peter O'Malley, P.O. Clements, and Gene Gollnick. Remembering Holman's contributions to the Dodgers, *Pasadena Star-News* columnist Joe Hendrickson wrote, "No man had done more to bring the Dodgers to Vero Beach and keep them there. His business skill was never doubted. He owned a motor sales company, was terminal manager for Eastern Airlines, and was a citrus grower and cattle rancher. There was never anything slow about Bud Holman. In 1930, his LaSalle roadster had been clocked at 104 miles per hour, a stock car speed mark at the time."

Following his father's death, Bump Holman decided to retire as the Dodgers' pilot in order to concentrate on the family business. Holman began as a co-pilot in high school and later flew three types of Dodger team planes: the Convair 440, the DC-3, the DC-6B, and the Electra. Bump Holman selected his replacement, Lewis G. Carlisle, from Eastern Airlines.

The first night game at Holman Stadium was played on March 28, 1968, against the Chicago White Sox. Dodger engineer Ira Hoyt announced that 376 of the new T-6 Quartz-Iodine lights would provide enough concentrated power to provide 40 percent more candlepower. Dodger minor league clubs also took advantage of the new lights.

The 1968 regular season also marked a year of transition for the organization. Familiar faces such as farm director Fresco Thompson and club stockholder Dearie Mulvey passed away, and general manager Buzzie Bavasi left in early June to become president of the San Diego Padres expansion team. Mulvey was the daughter of contractor Steve McKeever, who in 1912 helped build Ebbets Field in Brooklyn. She maintained a 58-year association with the Dodgers, which was the longest active baseball ownership in the majors.

Spring training 1969 featured the return of Roy Gleason, the outfielder who began the decade as a bonus-baby prospect and spent September 1963 with the Los Angeles ball club, hitting a double in his only major league at-bat. He returned to the minor leagues and, in 1967, was drafted into military service. During his tenure in Vietnam, Gleason received 14 military citations and became the only Dodger in Los Angeles history to win a Purple Heart. He also kept track of the Dodgers via mail from organization reports sent by Bavasi.

On July 24, 1968, Gleason was shot while his squad pursued a Viet Cong squad in the jungle near a canal. The force of the wounds to his left hand and left leg knocked his body into an irrigation ditch. As Gleason spent five months in a hospital recovery from shrapnel wounds, he dreamed of Vero Beach and a chance to be a ballplayer again. Those aspirations came true, and although Gleason didn't make the major league roster, he made a more improbable journey from the rice paddies and machine-gun fire in Vietnam to the tranquil postcard setting of a baseball camp. Gleason knew he was home again at Dodgertown.

TOMMY DAVIS. One of the top rookie prospects on the 1960 Dodgers was a power-hitting infielder. Davis later switched to the outfield and would win consecutive batting titles in 1962 and 1963. He still holds the Los Angeles single-season franchise records for most hits (230) and RBI (153).

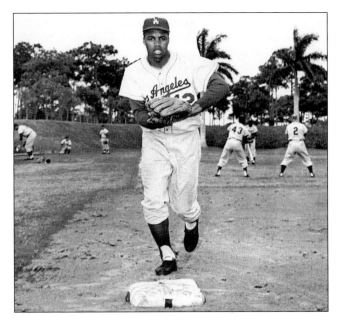

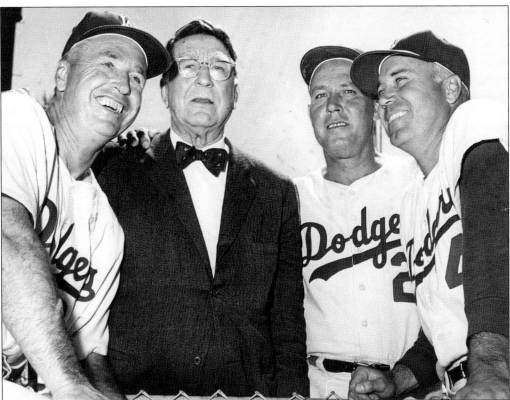

GRAND REUNION. Branch Rickey, the president of the Dodgers from 1942 to 1950, returned to Vero Beach in 1960 at age 78 for a spring visit with manager Walter Alston, coach Pete Reiser, and outfielder Duke Snider. Rickey was elected to the Baseball Hall of Fame in 1967, two years after his death.

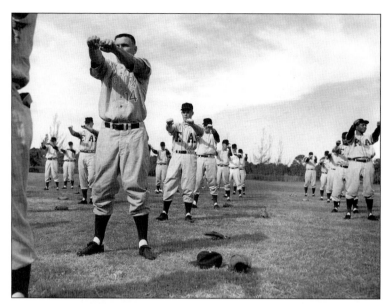

Workouts in the early 1960s at Dodgertown included different colored uniforms, along with "F.A." to designate free agents. According to farm director Fresco Thompson, players in the 1950s couldn't be released unless by a unanimous vote of the Dodger coaching staff. A lone dissenting vote could keep a player in camp for a further look.

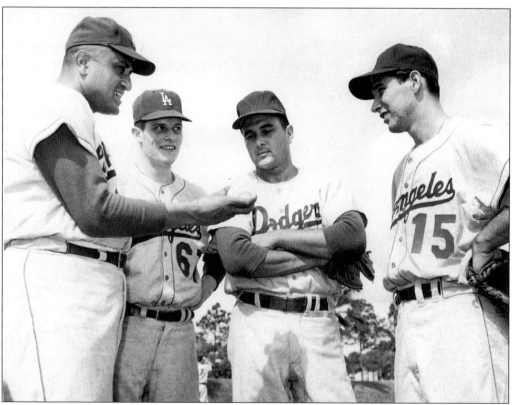

DON NEWCOMBE. Don Newcombe, who won 123 games with Brooklyn from 1949 to 1957, attempted a comeback with Los Angeles in 1961. Watching his spring tryout are, from left to right, rookie pitchers Pete Richert, Ron Perranoski, and Rick Warren. Note there is no logo on the cap of Perranoski, who made the club as a rookie in 1961 and appeared in 53 games. Newcombe spent the 1961 season in Japan as a pitcher and first baseman for the Chunichi Dragons.

SPRING REVIVAL. In addition to baseball games, the 1961 spring scene at Holman Stadium included a visit from Dr. Billy Graham. The famed evangelist held a Good Friday service during his Florida crusades.

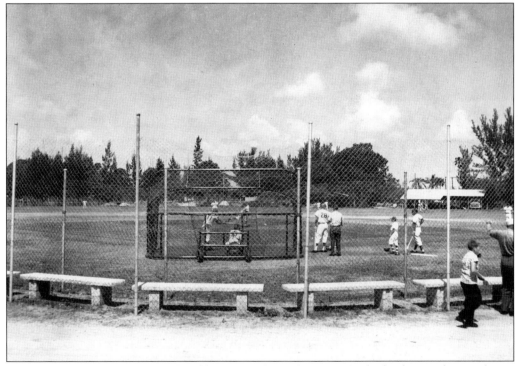

FIELD NO. 2. This is the view of Field No. 2 in the early 1960s. In the background is coach Leo Durocher (2), the former Brooklyn Dodger player and manager who served on Walter Alston's staff in Los Angeles from 1962 to 1964. When the Dodgers moved to Vero Beach in 1948, some of the early street signs read: "Durocher Trail," "Rickey Boulevard," "Flatbush Avenue," and "Ebbets Field."

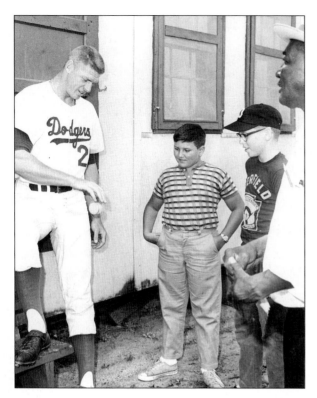

HONDO. Outside the Dodger clubhouse, fans watch as outfielder Frank Howard demonstrates his skills with a yo-yo. The 6-foot, 7-inch, 255-pound Howard hit 123 home runs with the Dodgers from 1958 to 1964. Dodger president Walter O'Malley often said this of Howard: "I'd rather clothe him than feed him."

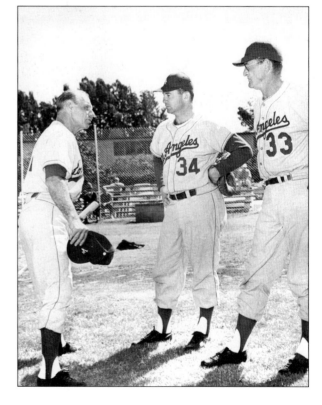

CONFERENCE TIME. As a coach in 1962, Leo Durocher consults with catcher Norm Sherry and pitching coach Joe Becker. Sherry was credited with helping pitcher Sandy Koufax find his control during the spring of 1961 after six inconsistent seasons at the major league level. Sherry's brother, relief pitcher Larry Sherry, was the MVP of the 1959 World Series.

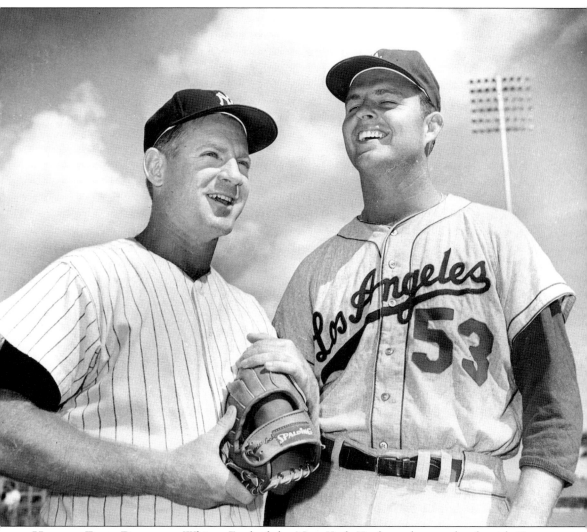

HALL-OF-FAME PITCHERS. Whitey Ford of the New York Yankees shares a laugh with Don Drysdale prior to a Dodgers-Yankees exhibition game. The Yankees beat the Brooklyn Dodgers in six of seven World Series showdowns between 1941 and 1956. Los Angeles reached the Fall Classic in 1963 and swept the Yankees in four straight games.

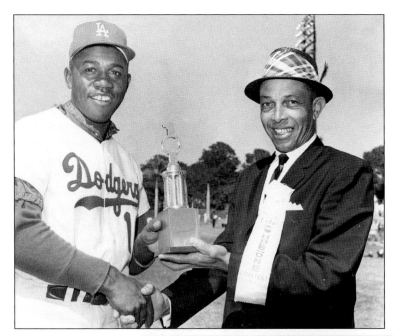

TEE TIME. Dodger infielder Jim Gilliam receives a golf award for the Coca-Cola Hole-In-One Contest. Gilliam, the National League's Rookie of the Year in 1953, eventually became a coach for the Dodgers following his 14-year playing career. His uniform number 19 was retired following his death in 1978.

MAURY WILLS. After eight seasons in the minor leagues, Maury Wills joined the Dodgers in 1959 and eventually became one of baseball's most exciting players. Wills stole a record 104 bases in 1962 en route to National League MVP honors. The current bunting cage at Dodgertown was dedicated in hor of Wills in 2003.

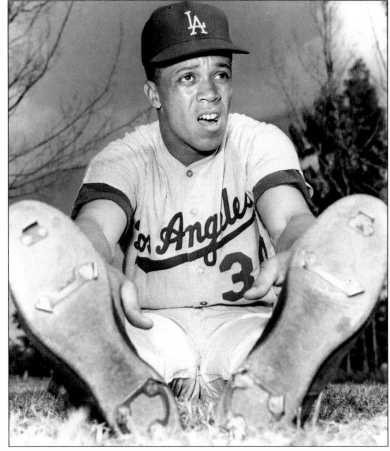

48

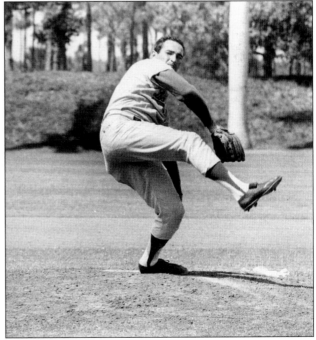

PICTURE PERFECT. Artist Nicolas Volpe portrays the imposing motion of pitcher Sandy Koufax (above) in a pencil sketch that graced the cover of the 1963 Dodgertown program. In real life (below), Koufax works on his form under the Florida sun without a cap. The Hall of Famer struggled with his control when he first joined the Dodgers in 1955, but he eventually posted a 129-47 record from 1961 to 1966. Koufax threw four no-hitters, including the only perfect game in franchise history in 1965.

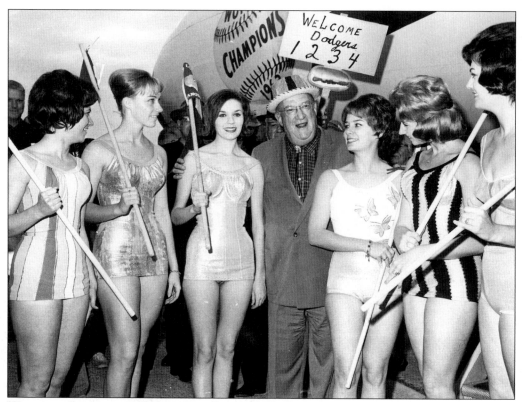

WELCOME COMMITTEE. Walter O'Malley receives the attention of bathing suit beauties upon the arrival of the World Champions to Vero Beach in 1964. The Dodgers won the 1963 World Series with a four-game sweep of the New York Yankees. The annual arrival and departure of the Dodger team plane during spring training became a community event, complete with music from the Vero Beach High School marching band.

BREAK TIME. Rookie pitcher Mike Kekich (center) watches while two Dodger couples, Don and Ginger Drysdale, and Sue and Bob Miller, work on a puzzle in the recreation room in 1965. Kekich appeared in five games for the Dodgers in 1965 and returned to Los Angeles for a brief stint in 1968. Miller appeared in 275 games with Los Angeles from 1963 to 1967.

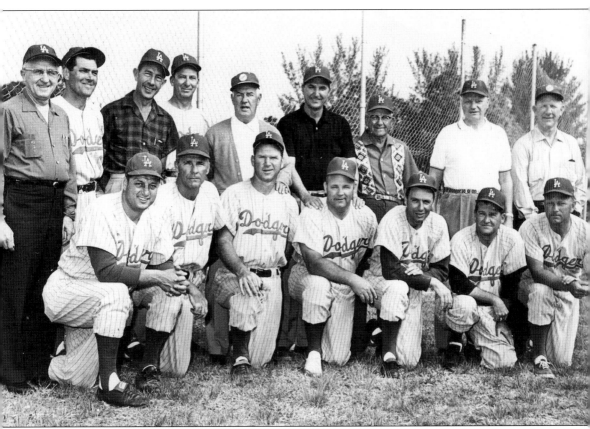

THE SCOUTS. Dodger minor league managers and coaches assemble for a team photo during the mid-1960s at Dodgertown. Many staff members later became major league managers, including Tommy Lasorda, Danny Ozark, and Roy Hartsfield. Walter Alston and Lasorda's staff in Los Angeles would include Monty Basgall and Red Adams.

TOURIST DESTINATION. The Dodgers and Philadelphia Phillies were saluted in this Florida storefront window in the mid-1960s. The Phillies have trained in Clearwater since 1947, one year before the Dodgers arrived in Vero Beach.

CIVIC PRIDE. The opening of the Vero Beach Little League season on March 30, 1964, featured some special guests from Dodgertown. From left to right are the following: (front row) Dodger president Walter O'Malley; Little Leaguer Mike Lyda, who threw the first pitch of the season; and pitcher Don Drysdale; (back row) Little League President Mike Monnin; past president and Player Agent John Studer; Dodgertown director Peter O'Malley; manager Walter Alston; outfielder Ron Fairly; and Vero Beach mayor Jack Sturgis.

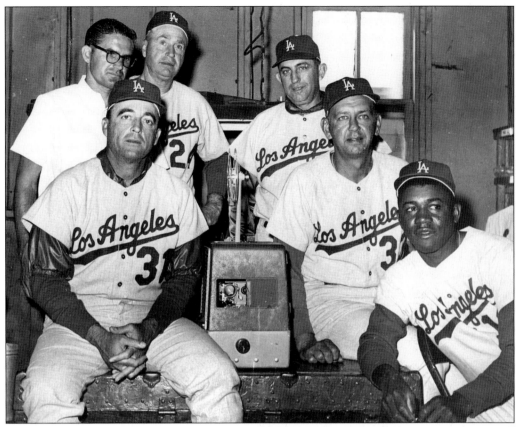

NEW COACHES. The Dodgers made wholesale changes to Walter Alston's coaching staff following the 1964 season. Alongside trainer Bill Buhler and Alston, the new faces are, from left to right, Preston Gomez, Harold "Lefty" Phillips, Danny Ozark, and Jim Gilliam, who would be a "player-coach" during the Dodgers' pennant-winning years in 1965 and 1966.

NEW CHALLENGE. Having built two ballparks in Vero Beach and Los Angeles, Walter O'Malley accepted his greatest challenge— the golf course. In the 1960s, O'Malley played nearly every day in spring training. With O'Malley in this 1966 photo is Dodger vice president Fresco Thompson.

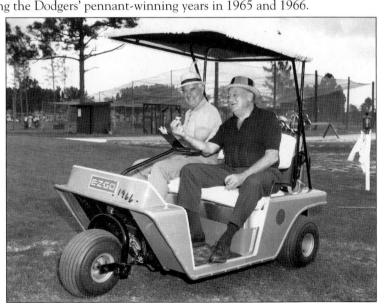

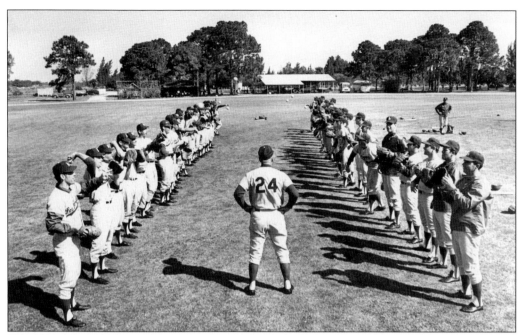

THE SKIPPER. Walter Alston supervises an early morning workout on Field No. 2 at Dodgertown. By the mid-1960s, Alston had become the dean of major league managers. He piloted the Dodgers to a record 2,040 regular season victories and four World Series championships during his Hall of Fame career from 1954 to 1976.

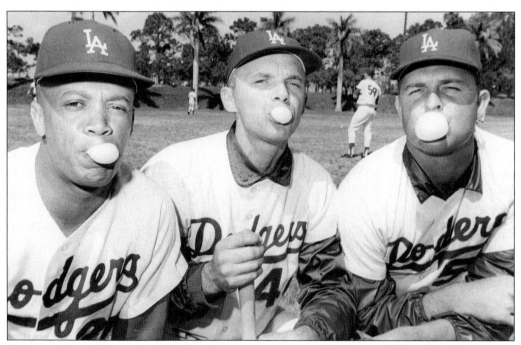

FUN AND GUM. Blowing bubbles for the cameras are teammates Maury Wills, Dick Traceweski, and Don Drysdale. Traceweski was a reserve infielder with Los Angeles from 1962 to 1965, and later became a major league coach.

SANCTUARY. In 1966, the Dodgers established their training camp as a wildlife sanctuary, teaming with the Florida Audubon Society and its Pelican Island chapter. The wildlife sanctuary idea was proposed by Walter and Kay O'Malley and fostered by Thomas T. Coxon of Vero Beach, a charter member of the Pelican Island chapter.

ANIMAL FARM. This young Dodgertown visitor and a sheep are part of the postcard setting in the 1960s. Along with the stadium and practice fields, there was a golf course, a lake, citrus groves, a canal at the south border, and a typical wildlife habitat of scrub palmetto and slash pine.

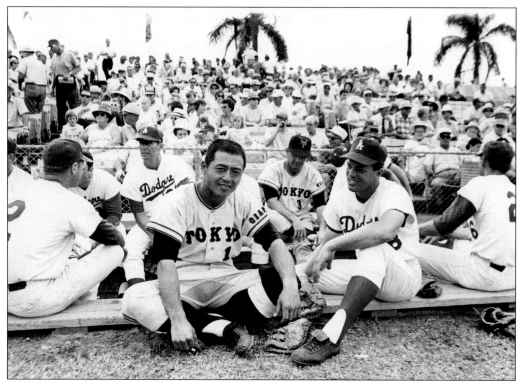

TOKYO GIANTS. Legendary slugger Sadaharu Oh and Dodger first baseman Wes Parker sit in the dugout at Holman Stadium prior to a 1967 exhibition game. Behind Oh are Dodger outfielder Jim Hickman and Giants' third baseman Shigeo Nagashima. Parker played in Japan for one season following his career with the Dodgers from 1964 to 1972.

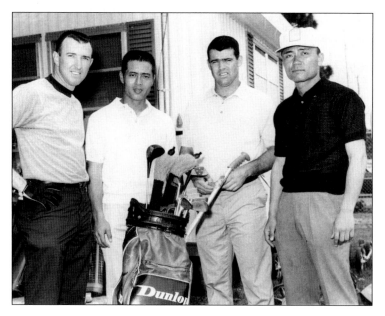

INTERNATIONAL APPEAL. The golf courses at Dodgertown served as the perfect setting for guests from around the world. The 1967 Tokyo Giants took advantage of their time away from the ballpark to enjoy a few rounds of golf. This Dodgers-Giants foursome features Claude Osteen, Sadaharu Oh, and Bob Bailey.

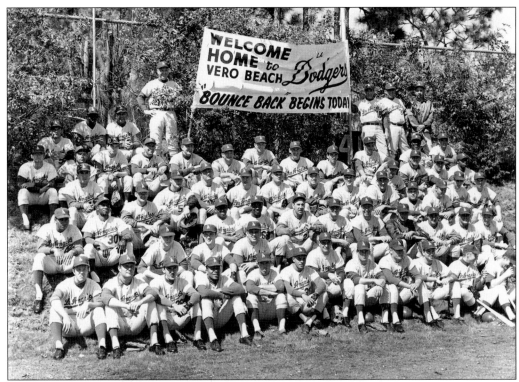

BOUNCED. After a 73-89 record and eighth-place finish in 1967, the Dodgers aimed to "bounce back" in 1968. The ball club tied for seventh in the National League with a 76-86 record in the final season before divisional play was adopted for the 1969 season.

WELCOME. Manager Walter Alston (24) extends his hand to new Dodgers for the 1968 season, including, from left to right, catcher Tom Haller, pitcher Jim "Mudcat" Grant, infielder Paul Popovich, and shortstop Zoilo Versalles.

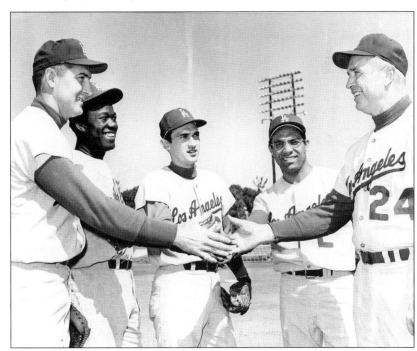

SQUEEZE PLAY. Catcher Jim Campanis poses in front of a citrus advertisement at the beginning of spring training in 1968. But Campanis didn't last long as a Dodger; his father, Al Campanis, sold his son to the expansion Kansas City Royals as one of his first transactions as the new Dodger general manager.

AMAZING. Gil Hodges returned to Dodgertown as manager of the New York Mets in 1968. One year later, he was in the dugout when the Mets won the first championship for a franchise that went 40-120 as an expansion entry into the National League in 1962. Hodges, who died of a heart attack at age 47 during spring training in 1972, remains a strong candidate for the Hall of Fame.

Four
The 1970s

St. Patrick's Day parties became a tradition with the Dodgers in the 1950s when Walter O'Malley became president of the organization. The family could trace its bloodlines to the famed County Mayo, Ireland, on his father's side. The 1952 party at the McKee Jungle Gardens in the Hall of Tara featured 130 guests, decorations, hats, skits, music, dancing, food, and drink. Everything was green that night—including the draft beer and the ice cubes.

March 17, 1970, carried extra significance as O'Malley's son Peter became president of the Dodgers. The senior O'Malley became Dodger Chairman of the Board and continued his work on the Major League Baseball Executive Council.

In 1971, the Dodgers purchased a 720-B Fan Jet from American Airlines, which made frequent trips to Dodgertown. The "Kay O'II" was the second Dodger-owned aircraft named for O'Malley's wife.

The Dodgers embarked on a major renovation project in 1972, replacing the barracks with 90 modern villas for the players, coaches, executives, and press. In 1974, a 23,000 square-foot administration building was constructed. The layout included a major league clubhouse, minor league clubhouse, medical department, dining room, kitchen, broadcasting studio, photo dark room, lounge, media workroom, two training rooms, two equipment rooms, and a laundry room.

On the field, the Dodger roster began a youth movement following the 1972 season. Gone were veterans like Frank Robinson, Wes Parker, Jim Lefebvre, and Maury Wills. Instead, the Dodgers gave prospects like Bill Buckner, Ron Cey, and Davey Lopes a chance to crack the starting lineup.

Many of those young players were products of a bountiful free agent draft in 1968. The major leagues' amateur draft began in 1965 and was a radical change from the method of player acquisition 20 years earlier when team president Branch Rickey and his scouts signed free agents at will during World War II. Rickey, considered the "father of the farm system" during his earlier tenure with the St. Louis Cardinals, stocked his camp with 600 players, allowing him to finance his minor league operation by selling off his extra talent.

By the summer of 1973, some of the pieces started to fall into place. Converted outfielders Lopes and Bill Russell took their places at second base and shortstop, respectively, with Cey anchoring third base. Rounding out the group was Steve Garvey, a scatter-armed third baseman from Michigan State University who stayed on the roster because of his pinch-hitting abilities. Manager Walter Alston penciled Garvey at first base on June 23 and the quartet would set a record by playing the next $8^1/_2$ seasons together. A second-place finish and a 95-66 record in 1973 weren't good enough to beat the Cincinnati Reds in the Western Division, but great things were just around the corner.

Prior to the 1974 season, the Dodgers made two major trades. They sent longtime outfielder Willie Davis to the Montreal Expos in exchange for relief pitcher Mike Marshall. They dispatched Claude Osteen to the Houston Astros and received Jimmy Wynn, a power-hitting

outfielder nicknamed "The Toy Cannon." The Dodgers rolled to a 102-60 record and captured the National League pennant, eventually losing in five games to the Oakland Athletics in the first World Series featuring two California teams. Wynn became the offensive catalyst with 32 home runs and Marshall became the first relief pitcher to win Cy Young Award honors after he set major league records in appearances (106) and innings pitched (208) by a reliever.

In his first full season as a starter in 1974, Garvey emerged as the National League's Most Valuable Player. As a youngster, Garvey grew up in Tampa, Florida. His father, Joe Garvey, was a bus driver whose spring assignments including transporting the Dodgers to their exhibition games. On several occasions, young Steve tagged along and played catch with some of the players on the sidelines. Steve eventually became a big fan of first baseman Gil Hodges, who hit 361 home runs for the Dodgers from 1947 to 1961, because of his manners and work ethic. Who could predict Garvey would play the same position and appear in a National League record 1,207 consecutive games between 1975 and 1983?

Alston retired following the 1976 season, capping a 23-year Hall of Fame career, which included a franchise record 2,040 regular season victories, seven National League pennants, and four World Series titles.

Thus began "The Tommy Lasorda Era," in which the former pitcher, scout, minor league manager, and Alston's third base coach took over the reigns. Lasorda proclaimed to "bleed Dodger blue" and other colorful stories eventually made the Pennsylvania native a household name. But Lasorda was also a master motivator and most of the homegrown talent on Lasorda's first Dodger squad in 1977 played for him at one time in the Dodger minor league system. The Dodgers won consecutive pennants in 1977 and 1978 to begin Lasorda's tenure, although both Octobers ended in disappointment with World Series losses in six games to the New York Yankees. The 1977 Dodgers featured baseball's first "30 Home Run Club," as the quartet of Garvey, Cey, Dusty Baker, and Reggie Smith became the first quartet on one team to hit at least 30 home runs in one season.

Back in camp, Harrison Conference Centers began operating Dodgertown in 1976. The efforts by Dodgertown director Dick Bird in 1972 to land a National Football League team paid off in 1974 when the New Orleans Saints signed a one-year deal. The Saints returned in 1976, the first of many NFL teams taking advantage of the Florida weather, especially during the playoffs.

The decade ended with the passing of Walter and Kay O'Malley within a month of each other in the summer of 1979. Just as Vero Beach resident and novice baseball fan Bud Holman made a significant contribution to the Dodger organization, the O'Malleys would leave a lasting imprint on the Vero Beach community. And Holman Stadium remains a symbol of their partnership and foresight.

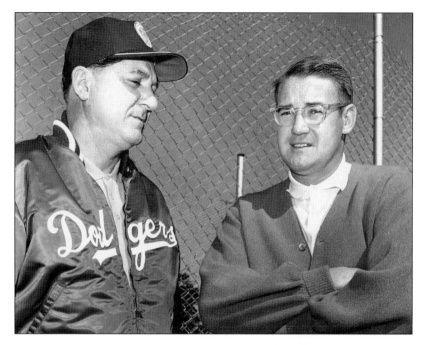

NEW LEADER. Peter O'Malley (right) became president of the Dodgers on March 17, 1970, as Walter O'Malley assumed a new role as chairman of the board. With O'Malley is general manager Al Campanis, the former scouting director.

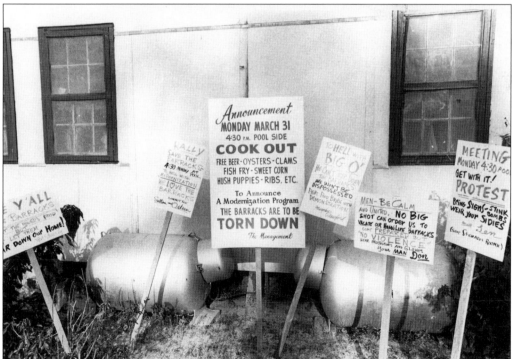

PICKET FENCES. After more than two decades of using the old naval barracks, the Dodgers constructed 90 modern villas in 1972. The departure of the barracks brought mock protest signs, including one from the "We Love The Barracks Committee," supposedly penned by Don Sutton and Claude Osteen.

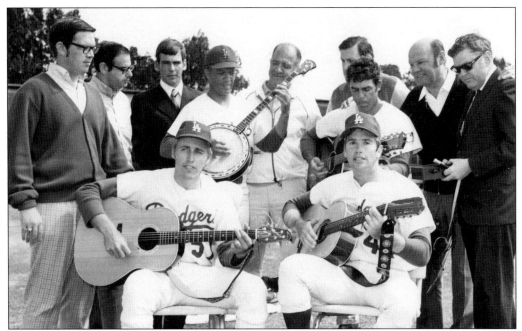

BANJO SHOW. Infielder Tommy Hutton and pitcher Alan Foster, backed up by Maury Wills and Fred Norman, perform in spring training to the "delight" of media members, including, from left to right, Dick Robinson, *Pasadena Star-News*; Jim Cour, *United Press International*; Bill Miller, *Santa Monica Evening Outlook*; and Bob Hunter, *Los Angeles Herald-Examiner*.

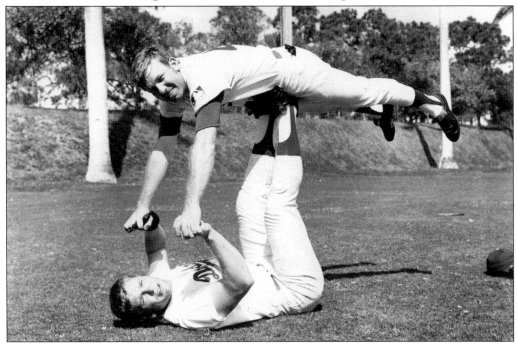

SUPERSIZE. Infielder Ted Sizemore, who won National League Rookie of the Year honors in 1969, gets a lift the following spring from teammate Bill Sudakis during morning exercises at Holman Stadium.

MARCH 18. It wasn't exactly St. Patrick's Day at Dodgertown, but the one-day delay in 1971 allowed time for a proper sendoff for the Tokyo Giants. This elaborate invitation was typical as the O'Malley family wanted the party to serve as the highlight of spring training. In the early days, Walter O'Malley had an elephant and ostrich painted green for a St. Patrick's Day party at McKee's Jungle Gardens, one of Vero Beach's tourist spots.

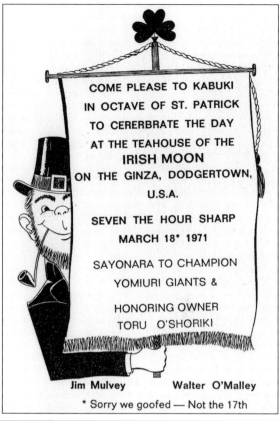

COME PLEASE TO KABUKI
IN OCTAVE OF ST. PATRICK
TO CERERBRATE THE DAY
AT THE TEAHOUSE OF THE
IRISH MOON
ON THE GINZA, DODGERTOWN,
U.S.A.

SEVEN THE HOUR SHARP
MARCH 18* 1971

SAYONARA TO CHAMPION
YOMIURI GIANTS &

HONORING OWNER
TORU O'SHORIKI

Jim Mulvey Walter O'Malley
* Sorry we goofed — Not the 17th

VILLA VIEW. To utilize the villa housing at Dodgertown, the camp housed the National Football League's New Orleans Saints for training camp beginning in 1974. Other NFL teams visited Dodgertown during the playoffs, taking advantage of the facilities. During the 1970s, the former baseball-only camp would expand into a conference center.

WHO'S ON THIRD? That was the question in the spring of 1971, when the Dodgers acquired Dick Allen (center) from the St. Louis Cardinals. Along with Allen are, from left to right, infield candidates Steve Garvey and Jim Lefebvre. In his only season with the Dodgers, Allen batted .295 in 155 games, with 23 home runs and 90 RBI while playing third base, first base, and outfield.

STORY TIME. While broadcast partner Jerry Doggett (far right) describes the action on the field, Vin Scully takes advantage of a side window at Holman Stadium to visit with Lee Scott, the Dodgers' traveling secretary. Scully and Doggett teamed for 32 seasons from 1956 to 1987, the longest tenure for a broadcasting duo in major league history.

No Fences. During the first two decades at Dodgertown, the palm trees lined the outfield perimeter at Holman Stadium. After outfielder Dick Allen crashed into a tree during spring training in 1971, the Dodgers erected a fence in front of the palm trees.

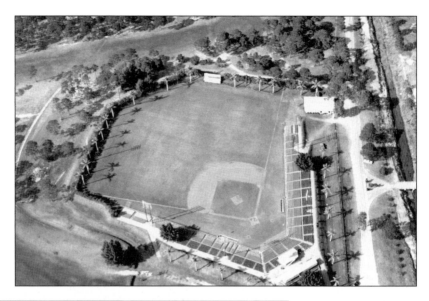

Labor Break. Prior to the Players Association's strike during spring training in 1972, union leader Marvin Miller visited Dodgertown to meet with the Dodger players. Miller accepted an invitation from Walter O'Malley to attend the team's St. Patrick's Day party.

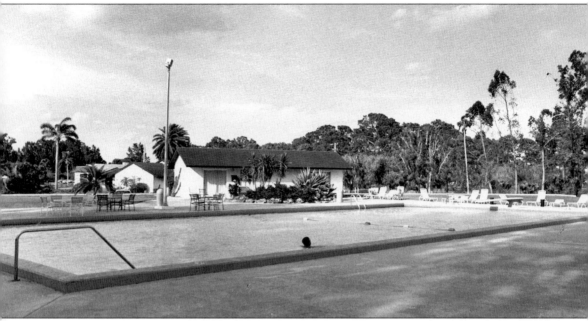

SWIMMING POOL. Another trademark of Dodgertown is the swimming pool, one of the main points of negotiation when the Dodgers pondered whether to switch their spring training headquarters to Vero Beach in 1948. The landscape in the area changed over the years, but the pool remained a popular destination for theme parties and general recreation.

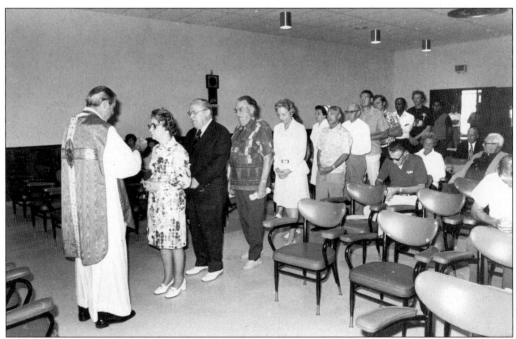

MEMORIAL DAY. Every spring at Dodgertown, a mass is conducted in memory of those who passed away during the previous year. It was initiated by Kay O'Malley to commemorate those individuals who worked at Dodgertown, or were guests, through the years.

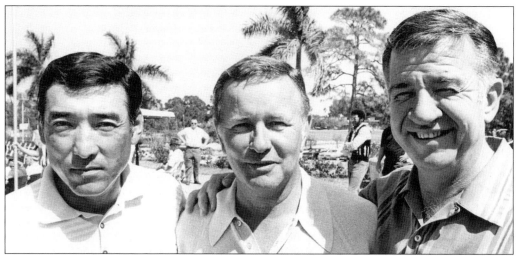

IN THE SUN. Equipment manager Nobe Kawano, broadcaster Jerry Doggett, and sportswriter Bill Miller strike a casual pose outside Field No. 2 at Dodgertown. Kawano joined the Dodgers in 1959 and became equipment manager in 1963. According to *Pasadena Star-News* columnist Joe Hendrickson, Miller had the best singing voice among Southern California media and Doggett was the best poker player.

OLD AND NEW. In 1972, centerfielder Willie Davis (left) was the dean of the Dodgers in terms of continuous service with the ball club. Davis poses with outfielder Frank Robinson, acquired from the Baltimore Orioles. In his only year with Los Angeles, the future Hall of Famer batted .251 in 103 games. Davis played with Los Angeles from 1960 to 1973.

LEFTY PARADE. Willie Crawford, Bill Buckner, and Von Joshua get ready for the 1973 season. The Dodgers posted a 95-66 record, but finished 3¹/₂ games behind the Cincinnati Reds in the National League West.

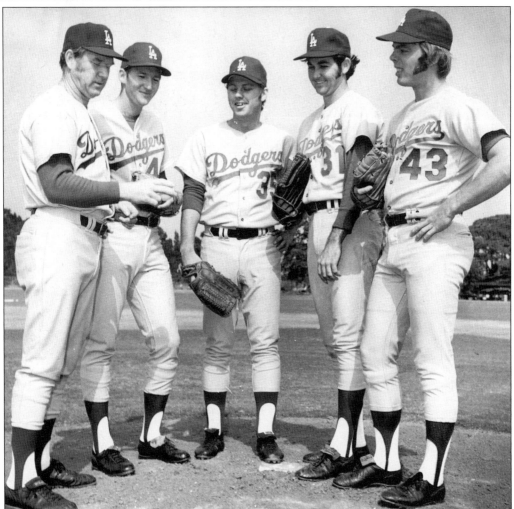

RED ADAMS. The former Pacific Coast League standout served as pitching coach of the Dodgers from 1969 to 1980. Youngsters on this 1973 staff include Charlie Hough, Bruce Ellingsen, Doug Rau, and Hank Webb.

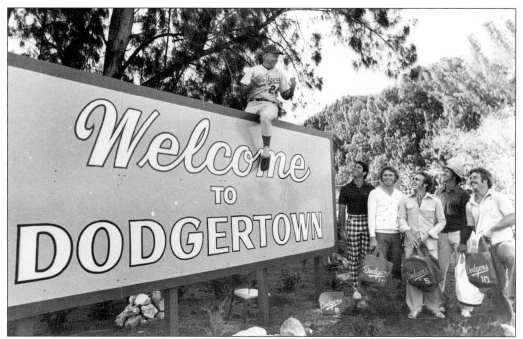

HIGH EXPECTATIONS. Manager Walter Alston greets his Dodger stars at the beginning of spring training. From left to right, Steve Garvey, Bill Russell, Ted Sizemore, Don Sutton, and Ron Cey greet Alston, who managed the Dodgers from 1954 to 1976.

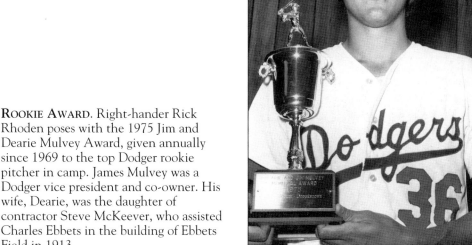

ROOKIE AWARD. Right-hander Rick Rhoden poses with the 1975 Jim and Dearie Mulvey Award, given annually since 1969 to the top Dodger rookie pitcher in camp. James Mulvey was a Dodger vice president and co-owner. His wife, Dearie, was the daughter of contractor Steve McKeever, who assisted Charles Ebbets in the building of Ebbets Field in 1913.

DEFENSIVE MENTOR. Dodger coach Monty Basgall helped the development of infielder Bill Russell, a converted outfielder who switched positions in the early 1970s and who eventually replaced Maury Wills at shortstop. Basgall also helped Steve Garvey's switch from third to first base and moved Davey Lopes from the outfield to second base.

JUAN MARICHAL. The former San Francisco Giants pitching star and Dodger nemesis joined Los Angeles in spring training in 1975, along with his family. Marichal pitched two regular-season games in April before retiring at age 37.

RETURNING HEROES.
Two stars from the 1974 season, first baseman Steve Garvey and outfielder Jimmy Wynn, are all smiles during the spring of 1975. Garvey batted .312 and earned National League MVP honors while Wynn slammed 32 home runs as the Dodgers reached the World Series.

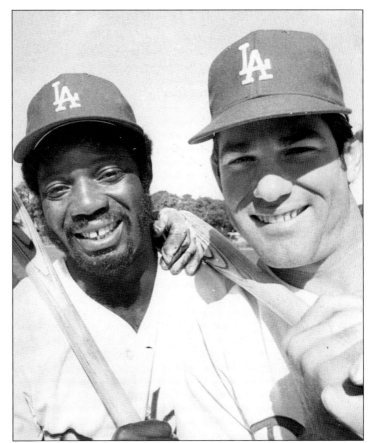

CHARLIE BLANEY. The director of Dodgertown from 1974 to 1987 often made creative suggestions to Dodger president Peter O'Malley in terms of improving the spring training facility. One of Blaney's ideas was the Dodgertown street signs, which honor Hall of Fame players and broadcasters. He also oversaw expansion of the facility in the 1970s.

FRONT GATE. In the early 1970s, the front entrance at Dodgertown included a map of the grounds. Harrison Conference Services took over the Dodgertown operation in 1977. Craig Callan, the Harrison representative for Dodgertown, later joined the ball club as a director in 1988. Callan eventually became a vice president and marked his 25th season at Dodgertown in 2004.

COOPERSTOWN INTERSECTION. These street signs honor Dodger Hall of Famers Jackie Robinson and Roy Campanella, who were teammates with Brooklyn from 1948 to 1956. Other street signs would honor Sandy Koufax, Roy Campanella, Duke Snider, Don Sutton, Tommy Lasorda, Walter Alston, Pee Wee Reese, along with broadcasters Vin Scully and Jaime Jarrin.

VIVA VILLAS. Replacing the barracks were rows of modern-day villas, which were comparable to quality accommodations at other Florida tourist destinations. With its unique baseball backdrop, Dodgertown became an ideal setting for companies to conduct business without the usual distractions of hotels or resorts.

INTERIOR DESIGN. A Dodger player who once stayed at the old naval barracks couldn't believe the difference in the interior of the modern layout that began in the early 1970s. During their final decade at Dodgertown, Walter and Kay O'Malley's villa was located at 162 Sandy Koufax Lane.

NET GAINS. The tennis courts at Dodgertown are located to the left of the dining room and lounge complex. One of the most prolific tennis players in camp during the 1970s was publicity director Fred Claire, who later became the team's general manager in 1987.

TOMMY JOHN. The left-handed pitcher, acquired from the Chicago White Sox prior to the 1972 season, won 87 games in six seasons with the Dodgers. In this spring training snapshot, John poses with his wife, Sally, and daughter Tamara.

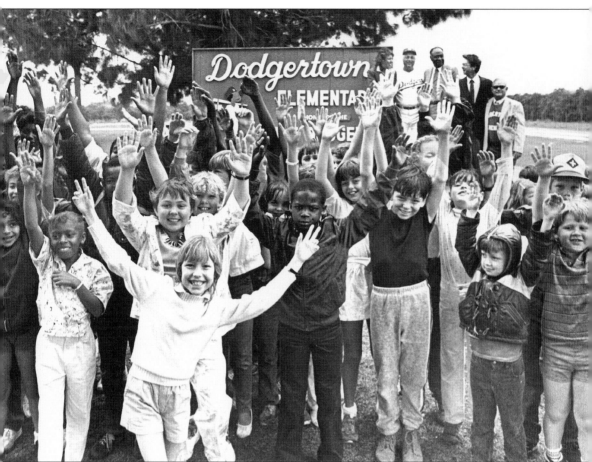

SCHOOL DAYS. Manager Tommy Lasorda greets students at the Dodgertown Elementary School. The Dodgers are active within the Vero Beach community, especially at their "adopted" school. Fifth grade students at Dodgertown Elementary School use the Holman Stadium setting for their graduation ceremonies. Fourth graders are invited to watch a ballgame during spring training. Other classes receive special gifts throughout the school year, including baseball cards, notebooks, lunch bags, rulers, and Dodger towels.

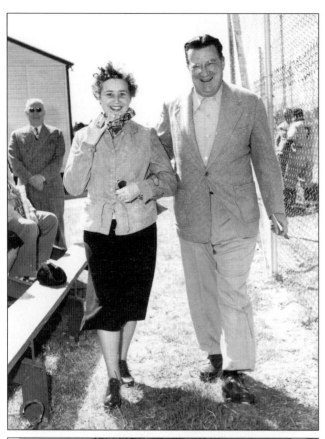

TOUCH OF CLASS. Walter and Kay O'Malley passed away within a month of each other in the summer of 1979. Their legacy of being gracious hosts to ballplayers, club officials, opponents, and umpires will forever be a staple in Dodgertown lore. In this 1965 photo (right), the O'Malleys celebrate the birthday of Anastasia Plucker, the Dodgertown nurse who dispensed her "salt solution" to players suffering from heat exhaustion.

FIVE
The 1980s

The new decade brought a new Dodger team to Vero Beach. The familiar major league faces from spring training still remained, including right-hander Don Sutton, the dean of the Los Angeles pitching staff and an Alabama native who broke into the majors at age 21 in 1966 alongside fellow starters Sandy Koufax, Don Drysdale, and Johnny Podres. The veteran squad featured Rick Monday, Steve Yeager, Charlie Hough, and Dusty Baker, along with the dependable infield of Steve Garvey, Davey Lopes, Bill Russell, and Ron Cey.

But the really young prospects belonged to the Single-A Vero Beach Dodgers, who joined the Florida State League (FSL) in 1980. The first Vero Beach manager was Stan Wasiak, known as "The King of the Minors," having become only the second manager to compile at least 2,000 career victories. Dodgertown director Charlie Blaney and Vero Beach general manager Terry Reynolds promoted the new minor league affiliate in the community. Bumper stickers and posters carried the message, "WE LOVE OUR VERO BEACH DODGERS." Radio station WTTB carried all road games and the team's symbol was a grapefruit. A new $60,000 bus was purchased for the team. Improvements were made to Holman Stadium in the aftermath of "Hurricane David" in 1979, which damaged the old press box and radio facilities. The Dodgers spent $200,000 on a new electronic scoreboard, a new press box, new lights, a renovated visitors clubhouse, and a new home clubhouse.

The Vero Beach Dodgers won their first Florida State League title in 1983 and Wasiak set the all-time record for most minor league victories, winning number 2,497 on Aug. 15, 1985. It was Wasiak's 36th season as a manager and he broke the previous record of 2,496 by Bob Coleman, who managed from 1919 to 1957.

The Vero Beach Dodgers provided local residents with plenty of highlights over the next two decades. Steve Sax, the 1982 National League Rookie of the Year, became the first Vero Beach player to reach the majors. The Vero Beach Dodgers won the FSL title again in 1990 with a catcher named Mike Piazza. The Florida State League All-Star Game was played at Holman Stadium in 1984 and 1991. Future Dodgers Dave Hansen, Paul Lo Duca, Eric Gagne, and Alex Cora all spent time in Vero Beach, along with third baseman Adrian Beltre, the 1997 FSL Player of the Year.

The Dodgers enjoyed success on the field during the 1980s as the only major league franchise to post two World Series titles in the decade. The first occurred in 1981, when "Fernandomania" captured Los Angeles. There was little warning in Vero Beach about pitcher Fernando Valenzuela, who figured to have a chance at the starting rotation after Sutton left the Dodgers via free agency and signed with the reigning National League West champion Houston Astros. When camp broke in Florida, Valenzuela returned to the West Coast without fanfare. But subsequent injuries to Jerry Reuss and Burt Hooton on the eve of spring training forced Lasorda to give the ball to Valenzuela, a 20-year-old who had never started a major league game, having pitched exclusively in relief during his September 1980 promotion. Valenzuela

fired a five-hit shutout against the Astros on Opening Day and he became an overnight sensation with an 8-0 record and five shutouts in his first eight starts.

The Dodgers won the first half of the 1981 season, the campaign split into halves because of a 50-day players' strike, and eventually defeated the Astros, Expos, and Yankees en route to a championship. It was also the last hurrah for the famous infield as Lopes was traded to the Oakland Athletics to make room for the 22-year-old Sax at second base.

The Dodgers won division titles in 1983 and 1985, but couldn't advance beyond the League Championship Series. In 1986 and 1987, the Dodgers suffered their first consecutive losing seasons under Lasorda and the first in Los Angeles history since the "post-Koufax depression years" of 1967 and 1968.

When the Dodgers stumbled to a seventh-place finish in 1967, general manager Buzzie Bavasi promised a "get tough" camp the following spring. The decree didn't work in 1968, primarily because the Dodgers didn't have the talent to compete.

That wasn't the story in 1988, when a talented roster welcomed the addition of free agent outfielder Kirk Gibson, whose fiery leadership sparked the Detroit Tigers to the 1984 World Series title. General manager Fred Claire, a former sportswriter who covered the Dodgers in the late 1960s, recognized Gibson's leadership might be the missing piece to the puzzle. His instincts were confirmed after the Dodgers' first spring training game at Holman Stadium. Prior to the national anthem, teammate Jesse Orosco smeared the inside of Gibson's cap with black shoe polish as a joke. Gibson soon discovered the prank and stormed off the field, demanding to know the identity of the offending party.

In a clubhouse meeting, an angry Gibson told his teammates that he wasn't interested in clowning around and his goal was to win a championship in Los Angeles. Those words served as a theme to the season as the Dodgers roared to the top of the National League West standings. While Gibson's leadership and style of play would eventually bring league MVP honors, teammate Orel Hershiser was embarking on his own journey for the ages. Hershiser ended the season with a streak of 59 consecutive scoreless innings, eclipsing the mark of 58 2/3 innings set by Don Drysdale in 1968.

Gibson and Hershiser continued their magic in the postseason. Hershiser earned MVP honors for his strong performances against the Mets in the League Championship Series and the Oakland Athletics in the World Series. Injuries limited Gibson to just one at-bat in the World Series, but it was the most memorable hit in Dodger history. Gibson limped off the bench as a pinch-hitter in Game 1 with the Dodgers trailing 4-3, with two out in the bottom of the ninth inning and a runner on base. After reaching a full count against reliever Dennis Eckersley, Gibson deposited a game-winning home run into the right field pavilion and limped around the bases, fulfilling his promise made seven months earlier in Vero Beach.

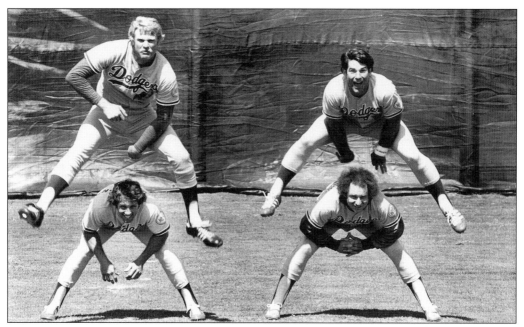

JUMP START. Starting the 1980 spring camp on a high note are Jerry Reuss, Jay Johnstone, Don Stanhouse, and Steve Garvey. Reuss and Johnstone became noted pranksters on the Dodgers and once joined the grounds crew in Los Angeles to rake the field in the middle of a game at Dodger Stadium.

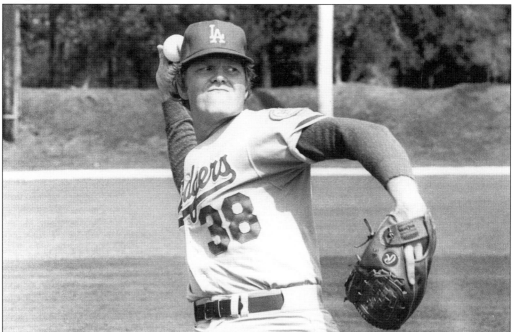

FREE AGENCY. The Dodgers, who avoided high-profile free agents following the 1977 and 1978 seasons, took the plunge by signing former Minnesota Twins right-hander Dave Goltz, who was coming off a 14-13 record with the Minnesota Twins in 1979. Goltz posted a combined 9-18 record in 1980 and 1981 and was released after two appearances in 1982.

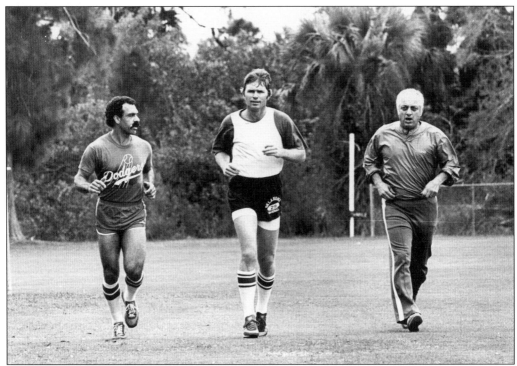

OFF AND RUNNING. In search of an elusive World Championship, infielders Davey Lopes and Bill Russell train with determined manager Tommy Lasorda, whose 1980 Dodgers lost a one-game playoff to Houston for the National League West title.

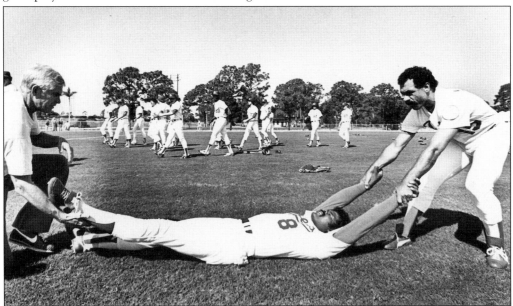

REGGIE SMITH. The outfielder was a top run producer for Los Angeles in 1977 and 1978, but injuries eventually took their toll. Smith played in only 68 games in 1979 due to knee, neck, and ankle injuries. During the spring of 1981, Smith stretches with the assistance of trainer Bill Buhler and second baseman Davey Lopes.

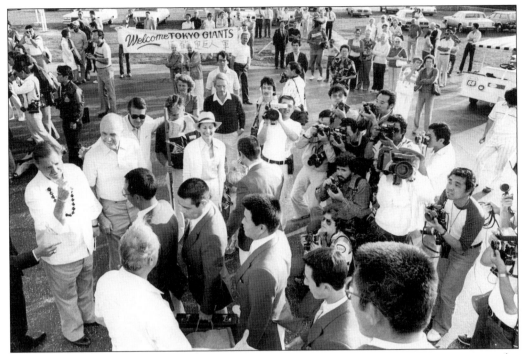

WELCOME, GIANTS. Not the San Francisco team, rather, the Japanese League juggernauts who made their fifth spring training appearance at Dodgertown in 1981. The relationship with the Giants began with the Brooklyn Dodgers' goodwill tour of Japan following the 1956 World Series.

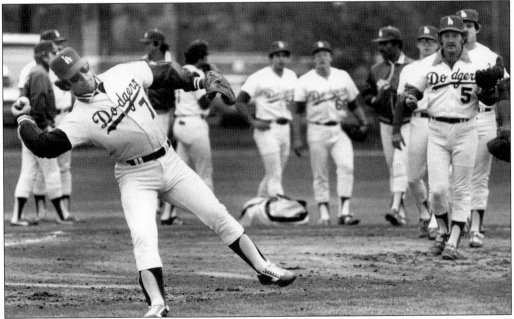

STEVE YEAGER. The popular catcher was one of the National League's top receivers during his career with Los Angeles from 1972 to 1985. In this photo, Yeager works on his throws to first base. Yeager earned tri-MVP honors in the 1981 World Series with teammates Ron Cey and Pedro Guerrero.

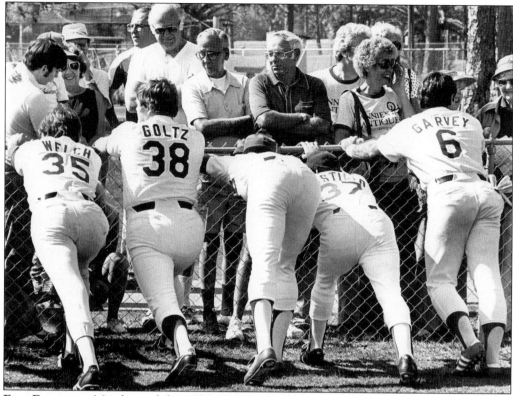

FAN FRIENDLY. Members of the 1981 Dodgers, including pitchers Bob Welch, Dave Goltz, Bobby Castillo, and first baseman Steve Garvey, stretch in front of spectators at Dodgertown.

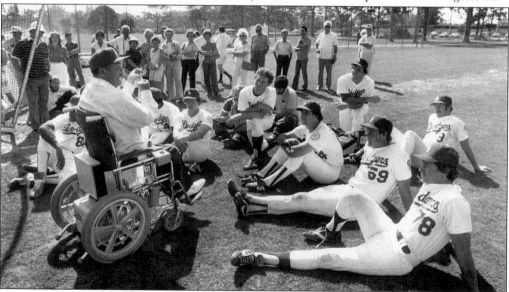

CAMPY'S BULLPEN. On the first day of spring training in 1982, Hall of Famer Roy Campanella lectures to the young Dodger catchers. Kneeling in the back row is Mike Scioscia, who played with Los Angeles from 1980 to 1992. Scioscia, who caught the most games in Los Angeles history, later managed the Anaheim Angels to a championship in 2002.

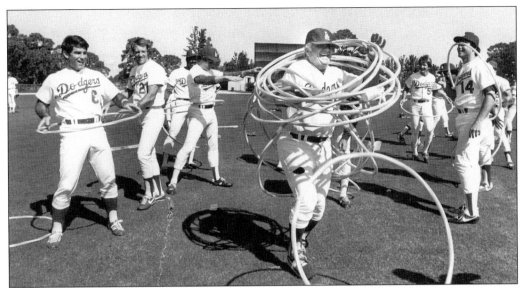

CHAMPIONSHIP RINGS. Coming off a World Series title in 1981, playful manager Tommy Lasorda enjoys some fun with Hula Hoops. Lasorda could afford to celebrate after Los Angeles defeated the New York Yankees in the Fall Classic, avenging previous October heartbreaks against the Bronx Bombers in 1977 and 1978.

SAX AND DRUMS. Second baseman Steve Sax plays the drums during a "50s Night" theme party at Dodgertown. The infielder was promoted to the Dodgers during the 1981 pennant race and he replaced Davey Lopes in 1982, earning National League Rookie of the Year honors.

HALL OF FAMERS. Posing at Dodgertown, from left to right, are Sandy Koufax, Walter Alston, Duke Snider, and Vin Scully. The quartet was together in Brooklyn when the Dodgers captured their World Series title in 1955, defeating the Yankees in seven games. Alston was named to the Hall of Fame in 1983 and passed away that fall at age 72.

STAR WATCH. Country music star Barbara Mandrell visits the Dodger camp in 1983. Mandrell wore uniform No. 7 and dutifully took her place between Rick Monday and Steve Yeager for the team's morning stretching exercises.

SLIDE. Shortstop Dave Anderson turns a double play in spring training while Atlanta's Brett Butler hits the dirt near second base during an exhibition game in 1983. Anderson was tabbed as the heir apparent to shortstop Bill Russell in the early 1980s, but remained in a reserve role throughout much of his Dodger career. Butler later played for the Dodgers from 1991 to 1997.

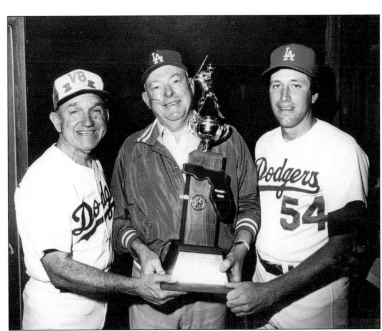

THE CHAMPS. Manager Stan Wasiak poses with the 1983 Florida State League trophy along with vice president Bill Schweppe and coach Gary LaRocque. Wasiak later set the minor league record for most career minor league victories as a manager (2,530) and was honored by the Hall of Fame in 1985.

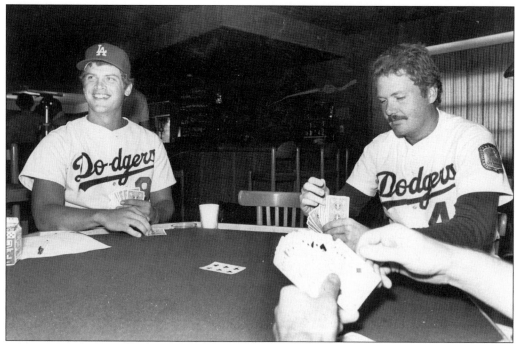

IN THE CHIPS. Greg Brock and Tom Niedenfuer play cards in the lounge, located next to the media workroom, which today is named after Hall of Fame sportswriter Bob Hunter. Brock replaced Steve Garvey at first base in 1983 and played five seasons in Los Angeles. Niedenfuer saved 64 games with the Dodgers from 1981 to 1987.

IKE IKUHARA. A graduate of Waseda University in Japan, Ikuhara became a special assistant to Dodger president Peter O'Malley and played a key role for the Dodgers and the international baseball community. Ikuhara was elected to the Japanese Baseball Hall of Fame in 2002. His son-in-law Acey Kohrogi is the Dodger director of Asian Operations.

VISITING DIGNITARIES. The Samsung Lions of Korea's professional league made their first trip to Dodgertown in 1985. From left to right are shortstop Bill Russell, executive vice president Fred Claire, manager Tommy Lasorda, Korean Baseball Organization commissioner Suh Jong Chul, baseball commissioner Peter Ueberroth, and former baseball commissioner Bowie Kuhn.

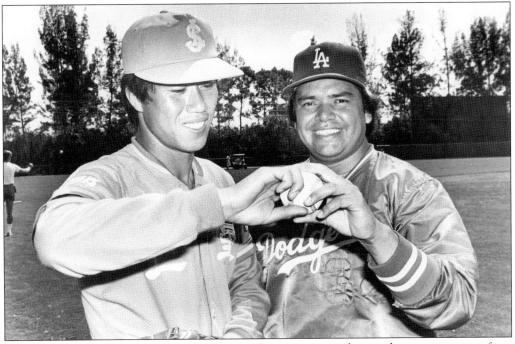

SAMSUNG LIONS. Dodger Fernando Valenzuela gives tips to his pitching counterpart from Korea. Valenzuela went 17-10 in 1985 and the Dodgers won the National League West, eventually losing in the NLCS against Jack Clark and the St. Louis Cardinals.

THEME PARTY. Manager Tommy Lasorda and his wife, Jo, share a dance during a "50s Night" party at Dodgertown in 1986. The couple celebrated their 54th wedding anniversary in 2004.

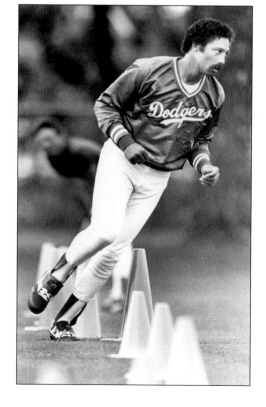

KEN LANDREAUX. The Dodgers acquired the outfielder from the Minnesota Twins during the final week of spring training in 1981 in a trade for infielder Mickey Hatcher. Landreaux, who caught the final out of the 1981 World Series on a pop fly by the New York Yankees' Bob Watson, spent seven seasons with Los Angeles.

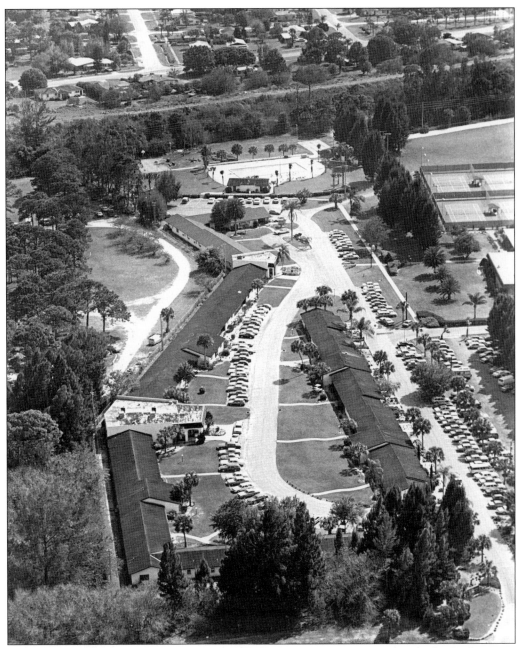

VIEW FROM THE TOP. This aerial photo from spring training in 1984 details the Dodgertown complex, including the villas, tennis courts, swimming pool, and surrounding trees. The Vero Beach Dodgers joined the Florida State League in 1980, prompting *Press-Journal* publisher John Schumann to write, "After all these years, the marriage between the Los Angeles Dodgers and Vero Beach has produced its first baby."

CATFISH. Before adopting the current "all-Dodger" Adult Camp format, the Dodgers staged an "ultimate" camp that included Yankees' Hall of Fame pitcher Jim "Catfish" Hunter. Other instructors from Cooperstown and their respective uniforms included Willie Stargell (Pirates), Harmon Killebrew (Twins), Bob Feller (Indians), Frank Robinson (Orioles), Duke Snider (Dodgers), Warren Spahn (Braves), Hoyt Wilhelm (Yankees), Lou Brock (Cardinals), Robin Roberts (Phillies), and Billy Williams (Cubs).

BUMP IN THE ROAD. During a theme party at Dodgertown, Dodger outfielder Pedro Guerrero poses with Japan League pitcher Shoji Sadoka. Just two weeks after this photo was snapped in 1986, Guerrero tore his knee ligaments while attempting to slide into third base during the team's final exhibition game. Coming off a 35-home run season in 1985, Guerrero was limited to just 31 games in 1986 and the Dodgers finished fifth with a 73-89 record.

REMEMBERING JACKIE. Hall of Famers Roy Campanella, Pee Wee Reese, and Duke Snider admire a portrait in the Dodgertown hallway of Jackie Robinson, a Brooklyn Dodger standout from 1947 to 1956. Robinson, who broke baseball's color barrier and became one of the nation's most memorable personalities of the 20th century, passed away in 1972 at age 53.

PITCHER PERFECT. Left-hander Jerry Reuss shares a laugh in 1986 with Hall of Famer Sandy Koufax, who served as a Dodger minor league instructor. Reuss won 86 games for the Dodgers from 1979 to 1987, including a no-hitter in 1980 against the Giants. The minor league pitcher in the foreground is John Wetteland, who made his debut with the Dodgers in 1990 and later won MVP honors as the New York Yankees' closer in the 1996 World Series.

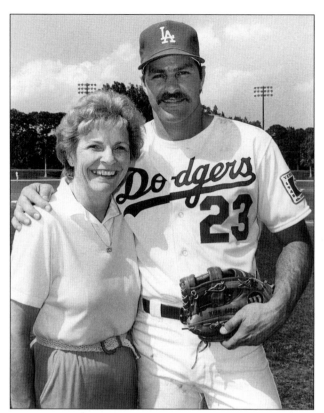

THE MVP. Outfielder Kirk Gibson, posing with his mother, Barb, at Dodgertown, joined the Dodgers as a free agent in 1988. The no-nonsense outfielder objected to a prank prior to the Dodgers' first exhibition game at Holman Stadium. Gibson challenged the Dodgers in the clubhouse and his teammates responded to his leadership. Gibson batted only .276 in 1988, but earned MVP honors as the Dodgers won the National League West crown.

PRANKSTER. Pitcher Jesse Orosco placed black shoe polish on the inside of Kirk Gibson's cap prior to a spring training in 1988, a prank that initially upset Gibson but set the tone for a championship season. Orosco appeared in 55 games and posted nine saves for the Dodgers in 1988. He returned in 2001 and pitched for Los Angeles at age 45 in 2002.

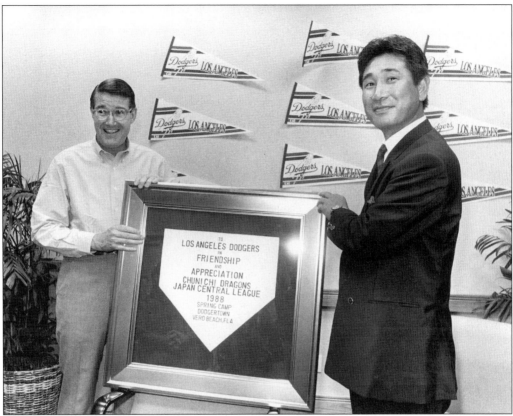

CHUNICHI DRAGONS. The Japan Central League team made its first appearance at Dodgertown in 1988. Dragons manager Senichi Hoshino gives Dodger president Peter O'Malley a commemorative home plate, which today is displayed in the main lobby area just outside the camp's dining room.

FROM RUSSIA WITH GLOVE. Soviet national baseball team coaches Gela Cheehradge and Alexander Adratov spent four days at Dodgertown in 1988. In addition to watching the major league Dodgers, the Soviet coaches also compared training notes with the Chunichi Dragons.

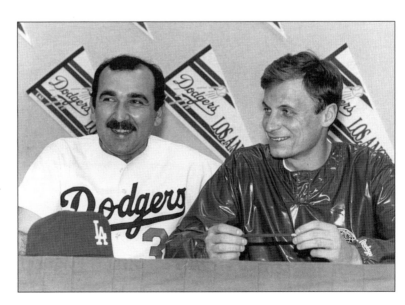

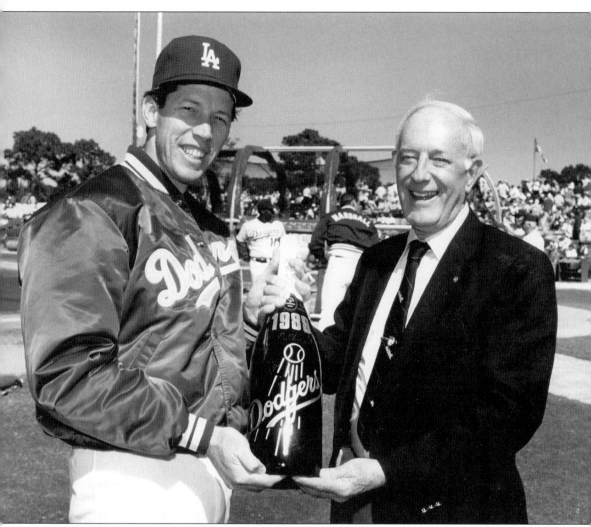

TOAST OF THE TOWN. Pitcher Orel Hershiser presents a bottle of champagne to a representative from the Baseball Hall of Fame during pre-game ceremonies at Holman Stadium in 1989. Hershiser enjoyed one of the most memorable seasons for a pitcher in baseball history in 1988. He went 23-8 and ended the season with a record streak of 59 consecutive scoreless innings, surpassing the previous mark of 58 2/3 innings set by Dodger right-hander Don Drysdale in 1968. Drysdale was a Dodger broadcaster in 1988 and greeted Hershiser in the dugout when he broke the record during his final start in San Diego. Hershiser also captured MVP honors in the League Championship Series and World Series as the Dodgers won their fifth championship in Los Angeles.

Six
The 1990s

Although the Dodgers didn't win any pennants for the first time since the 1930s, the 1990s were filled with truly unique circumstances at Dodgertown. Labor battles between the owners and players affected spring training with work stoppages in 1990 and 1995, which greatly affected tourism and the local economy.

Non-baseball headlines were nothing new, of course, as the first celebrated baseball holdout occurred in 1966 when Dodger pitchers Sandy Koufax and Don Drysdale didn't report to Vero Beach, negotiating as a tandem following their combined 52 victories during the regular season and World Series. This was the only option under baseball's reserve clause, and free agency wouldn't arrive until pitchers Andy Messersmith and Dave McNally won their grievance against baseball following the 1975 season. The Dodgers drew a crowd of 8,200 fans against the Yankees at Holman Stadium in 1979, but their 1980 match up was canceled because of a players' strike on April 1, which wiped out the rest of the major leagues' 92 exhibition games.

One of the biggest stories of the decade occurred in 1995, when Japanese pitcher Hideo Nomo reported to minor league camp at Dodgertown. Nomo spent his first five seasons with the Kintetsu Buffaloes of the Japanese Pacific League. In his attempt to become the first Japanese-born player to join a major league team after having played professionally in Japan's Central or Pacific League, Nomo's every move during spring training was scrutinized back home in Japan. It had been 30 years since Masanori Murakami pitched for the 1964–1965 San Francisco Giants, and the relief pitcher had been pressured by his homeland to return to Japan. The large gap in time fueled the debate over whether players from Japan could compete in the United States.

During this time, the Dodgers had become leaders within the international baseball community. The Tokyo Giants made spring training visits to Dodgertown in 1961, 1967, 1971, 1975, and 1981. The Chunichi Dragons visited in 1988. Other international guests included the Samsung Lions from Korea (1985, 1992–1993), the Nigerian National Baseball team (1993), and the Moscow Red Devils (1993). Dodger scouts Tommy Lasorda and Kenny Myers gave baseball clinics in Japan in the early 1960s and coaches from Nicaragua, Russia, Australia, China, Holland, Italy, Korea, Japan, Taiwan, and Nigeria in turn studied the training techniques of the Dodger staff in Vero Beach. In 1994, Dodger right-hander Chan Ho Park became the first South Korean-born player to appear in the majors.

In 1995, the Dodgers' Director of Asian Operations was Acey Kohrogi, the son-in-law of Ike Ikuhara, the former assistant to Peter O'Malley who would be named to the Japan Baseball Hall of Fame in 2002 for his contributions to the international baseball community. Kohrogi served as a liaison to Nomo and helped as the pitcher adjusted to life in the United States.

With a support structure in place in Vero Beach and Los Angeles, Nomo responded to the pressure and earned National League Rookie of the Year honors, posting a 13-6 record, 2.54 ERA, and league-leading 234 strikeouts. He started the All-Star Game and set a single-game

Dodger rookie record with 16 strikeouts against the Pirates on June 14 at Dodger Stadium, eclipsing the Brooklyn record set in 1954 by Karl Spooner, who fanned 15 batters.

Nomo's starts were carried live to Japan on NHK-TV and a 12-hour special on Nomo was televised on New Year's Eve in 1995. The Dodgers traded Nomo during the 1998 season, but he returned as a free agent in 2002. By that time, Japanese players were no longer a novelty in the majors; Seattle Mariners' outfielder Ichiro Suzuki had captured both Rookie of the Year and MVP honors in his first season in 2001.

Nomo's success also occurred during the Dodgers' string of five consecutive Rookie of the Year winners: first baseman Eric Karros (1992), catcher Mike Piazza (1993), outfielder Raul Mondesi (1994), Nomo (1995), and outfielder Todd Hollandsworth (1996).

The 1996 Dodgers arrived in Vero Beach as the reigning National League champions. But nobody realized that spring training would be the final appearance as manager for Tommy Lasorda. The skipper suffered a mild heart attack in the middle of the season and subsequently announced his retirement from the dugout due to health reasons. Lasorda finished with 1,599 regular season victories and two World Series titles. His election to the Baseball Hall of Fame in 1997 seemed to be the crowning achievement. But Lasorda never put aside his competitive fire and he accepted a challenge in 2000 to coach Team USA in the Olympic Baseball competition in Australia. Lasorda's underdog squad shocked Cuba in the championship game and came home with the gold medal.

In March 1998, Major League Baseball owners approved the sale of the Dodgers from the O'Malley family to The Fox Group. While it was a time to reflect on the successful O'Malley era, the spring of 1998 was also a chance to celebrate the selection of Spanish language broadcaster Jaime Jarrin to the Hall of Fame. Jarrin received the Ford C. Frick Award, won by Dodger broadcaster Vin Scully in 1982 and former Brooklyn broadcaster Red Barber in 1978. Watching Jarrin celebrate his election was an especially gratifying time for those at Dodgertown who remembered his near-fatal auto accident at night in Vero Beach in 1990, when Jarrin was struck in a head-on collision by a car without its lights on. His seatbelt saved Jarrin's life, but it would take months of hospitalization to battle a series of setbacks and infections before he could return to the ballpark.

Another Hall of Fame honoree in 1998 was former right-hander Don Sutton, who pitched for Los Angeles from 1966 to 1980 and in 1988. Sutton won 324 games during his career and his No. 20 joined the other retired uniform numbers at Dodger Stadium: Pee Wee Reese (1), Tommy Lasorda (2), Duke Snider (4), Jim Gilliam (19), Walter Alston (24), Sandy Koufax (32), Roy Campanella (39), Jackie Robinson (42), and Don Drysdale (53).

NEW BUILDING. Dodgertown featured a new indoor batting facility in 1990. The batting cages were located adjacent to the minor league clubhouse and the renovated administration offices in the complex located between the villas and Fields Nos. 1 and 2.

THE BAT CAVE. With indoor batting facilities, poor weather usually couldn't prevent the Dodgers from working on spring training drills. The original outdoor batting cages located behind Holman Stadium remained in place through the 1990s and were used by adult campers in February and November sessions.

**THE SANTA-EXPRESS IS ARRIVING AT DODGERTOWN
FRIDAY, MARCH 20, 1992**

6:00 P.M. Poolside Reception ∽ 7:00 P.M. Dinner

*The kids will enjoy an array of festival activities and a
fun-filled evening to remember.*

RSVP 569-4900
X310 Donna

CHRISTMAS PARTY. The Christmas party at Dodgertown became a tradition under Dodger president Peter O'Malley. It was an exciting time for children of the Dodger players and staff as each received a specially selected present at the party.

ARTFUL DODGER. This picture was drawn by Tricia Crews, daughter of Dodger reliever Tim Crews, who pitched for Los Angeles from 1987 to 1992. The illustration was included on the back of the invitation above, celebrating the family atmosphere at the Dodgertown camp.

FISH-EYE LENS. This unique angle captures the hallway leading from the dining room area toward the minor league clubhouse and Dodger administration offices in the early 1990s. Along the path is a workout room, laundry room, and umpires room.

MIKE PIAZZA. A 62nd-round draft choice in 1988, Mike Piazza would eventually set the major league record for most home runs by a catcher. Piazza batted .250 in 88 games at Single-A Vero Beach in 1990 and helped the Dodgers win the Florida State League title. In 1993, Piazza established franchise rookie records in 1993 with 35 home runs and 112 RBI.

CONFERENCE ROOM. Named after former Dodger greats Sandy Koufax and Roy Campanella, these rooms became centerpieces of the conference center plans. The meeting rooms were sound-proofed and equipped with cameras, TV monitors, tape recorders, movie slide and projection devices to encourage use by outside companies during seminars or conventions.

BROTHERS IN ARMS. The 1993 camp was truly a family affair as brothers Jesus, Pedro, and Ramon Martinez wore Dodger uniforms. Ramon posted a combined 37 victories for Los Angeles in 1990 and 1991 and pitched a no-hitter for Los Angeles in 1995. Pedro Martinez became a star in the majors after his 1993 trade from the Dodgers, winning three Cy Young Awards with the Expos and Red Sox.

ANNIVERSARY. On the 40th anniversary of the Holman Stadium dedication in 1993, the sons of Walter O'Malley and Bud Holman stand in front of the 1953 plaque that honors the Vero Beach businessman and former Dodger president. Bump Holman (left) and Peter O'Malley first met as teenagers and their friendship has lasted more than five decades.

Roy Campanella. The 40th anniversary celebration at Dodgertown in 1993 would be the Dodger catcher's final spring in Vero Beach. The Hall of Fame catcher passed away at age 71 that summer, 35 years after an auto accident left the three-time National League Most Valuable Player paralyzed.

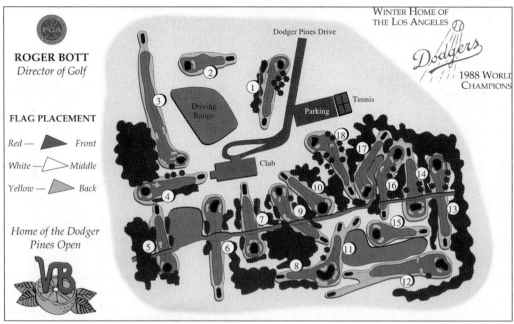

ROGER BOTT
Director of Golf

Dodger Pines Drive

2

1

3

Driving
Range

Tennis

Parking

FLAG PLACEMENT

Red — Front

White — Middle

Yellow — Back

*Home of the Dodger
Pines Open*

VB

Club

18
17
14
16
13
10
4
9
7
15
5
6
11
8
12

GOLF CARD. This scorecard shows the layout of the former Dodgertown 18-hole golf course, which was designed with considerable input from Dodger president Walter O'Malley in 1965. Dodgertown director Dick Bird suggested the title "Safari Pines" because O'Malley had done big game hunting in Africa and the clubhouse could be decorated with his trophies. O'Malley stuck to the baseball theme and waitresses wore Dodger shirts with the names of famous players on the back.

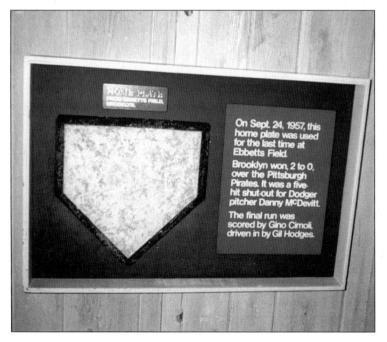

HOME PLATE
EBBETTS FIELD,
BROOKLYN

On Sept. 24, 1957, this home plate was used for the last time at Ebbetts Field.

Brooklyn won, 2 to 0, over the Pittsburgh Pirates. It was a five-hit shut-out for Dodger pitcher Danny McDevitt.

The final run was scored by Gino Cimoli, driven in by Gil Hodges.

EBBET'S MEMORIES. This was the home plate used for the final game played at Brooklyn's Ebbets Field in 1957. It was on display in the lobby of the Dodger Pines golf course, along with other Dodger photos and memorabilia. The final out in the 1957 road finale was made by Brooklyn's Bob Kennedy, whose son, former major league catcher Terry Kennedy, would become a Dodger minor league manager in 2004.

LOBBY DISPLAY. These seats from Holman Stadium rest in front of a large mural of Dodger Stadium in Los Angeles. Also displayed is a framed home plate commemorating the 1988 visit to Dodgertown by the Chunichi Dragons, along with a plaque on one of the stadium seats saluting Stan Wasiak, the all-time leader for most victories by a minor league manager. Wasiak set the record with the Vero Beach Dodgers on August 15, 1985.

UNIQUE SPRING. The 1995 spring training opened with a team of "replacement players," signed to Dodger minor league contracts due to a labor dispute that ultimately prompted the cancellation of the 1994 playoffs and World Series. These Dodgers played exhibition games in March, but returned to the minor leagues after the situation was resolved in early April.

平成7年5月8・15日発行(毎週月曜日発行)第50巻・第20号(通算第2113号)昭和21年10月12日第三種郵便物認可

週刊ベースボール

5.8·15合併号340円

ゴールデン・ウィーク
特大号

クローズアップHERO

大リーガー・野茂ドジャースの挑戦!!

迷走・長嶋巨人に
お嘆きのアナタへ…

ベースボール・マガジン社発行

TRAIL BLAZER. In 1995, Hideo Nomo became the first player to appear in the majors after beginning his career in Japan's professional leagues since the Giants' Masanori Murakami in 1964 and 1965. The former Kintetsu Buffaloes star made the adjustment to the United States and won the Rookie of the Year award, posting a 13-6 record with a league-leading 236 strikeouts.

CAMPERS FUN. One of the attractions to the Dodger Adult Camp is the friendships forged between great Dodgers of the past and their loyal fans who have a chance to spend a week with their heroes. Many campers return every year and become camp "veterans," along with the instructors who are invited back based on feedback from the campers. In this photo, former Brooklyn Dodger pitcher Preacher Roe shares a moment with camper Neil Adams from Southern California.

Hot Rod. Outfielder Henry Rodriguez slammed four home runs in one exhibition game at Holman Stadium in 1995. The power display served as an audition for other major league teams as Rodriguez was traded later that season to the Montreal Expos. Rodriguez hit a career-high 36 home runs with Montreal in 1996.

No Game. Rains at Dodgertown create a beautiful reflection in the outfield pool of water, but there will be no work on this day at Holman Stadium. Weather generally isn't a problem during the spring, although heavy rains throughout Florida in 1959 prompted the Dodgers to fly to Cuba to play the Cincinnati Reds with Fidel Castro in attendance.

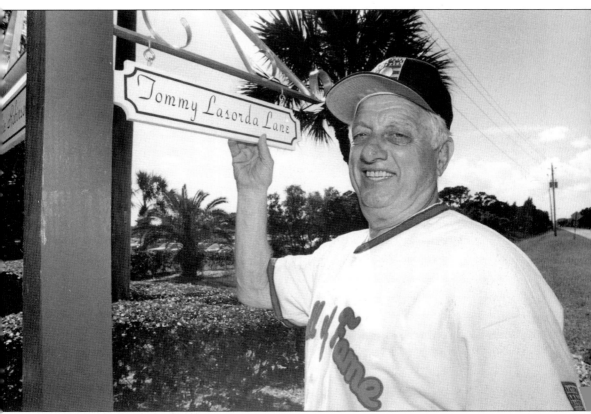

COOPERSTOWN CALLING. After 20 seasons as Dodger manager, Tommy Lasorda was elected to the Baseball Hall of Fame in 1997. Lasorda became a senior vice president and later guided Team USA to a gold medal in the 2000 Summer Olympics in Australia.

CHAN HO PARK. Appearing at a St. Patrick's Day party, the right-hander pitched for the Dodgers from 1994 to 2001. He became the first pitcher from South Korea to appear in the major leagues. Park led the Dodgers in victories in four seasons, including a career-high 18 wins in 2000.

ROSS PORTER. The award-winning television reporter joined the Dodger broadcast team of Vin Scully and Jerry Doggett in 1977. Porter set a major league record in 1989 when he broadcast all 22 innings of a Dodgers-Expos game in Montreal. The Oklahoma native attended this St. Patrick's Day party with his wife, Lin.

DODGER DANCERS. Proving talent isn't confined to the baseball field, these dancers were a big hit at the 1997 St. Patrick's Day festivities. From left to right, they are Betty Fernandez, Jan Conti, Jo Giesecke, Luchy Guerra, Jackie Shoemaker, Lisa Vavra, and Mary Debus.

KEYS TO DODGERTOWN. Honorees at this St. Patrick's Day ceremony are minor league department assistant Dianne Mesa, trainer Bill Buhler, *Long Beach Press-Telegram* sportswriter Gordie Verrell, and National League umpire Dutch Rennert.

HAPPY DAY. Dodger general manager Fred Claire makes his point to the delight of former Los Angeles pitcher Don Sutton, who was at Dodgertown in 1998 to celebrate his selection to the Baseball Hall of Fame. Sutton won 324 games during his career and holds the all-time Dodger franchise marks for most victories (233), games pitched (550), innings (3,814), strikeouts (2,696), and shutouts (52).

JAIME JARRIN. The Spanish voice of the Dodgers was elected to the Hall of Fame in 1998. Jarrin, posing at Dodgertown with manager Bill Russell, joined the Los Angeles broadcasting team in 1959. He translated for rookie pitcher Fernando Valenzuela during his magical Cy Young Award season in 1981 and helped the pitcher make the transition to the broadcast booth when Valenzuela rejoined the Dodger organization in 2003.

BILLY DELURY. The former Dodger traveling secretary and current assistant to the broadcasting team stands at the podium during the St. Patrick's Day party in 1997. DeLury first arrived in Vero Beach from the Brooklyn Dodger offices in 1950. His first assignment was working in the mailroom. In a 1988 interview with the *Press-Journal*, DeLury noted there wasn't widespread development in the Vero Beach area. "East of the railroad tracks, you didn't see too many buildings," he said. "Once you crossed the river, it seemed as though you had entered a jungle."

ERIC KARROS. Playing behind Todd Benzinger and Kal Daniels, the first baseman from UCLA enjoyed a solid spring in 1992, but appeared headed to the minor leagues because there was no room on the major league roster. An injury to reliever Jay Howell gave Karros the chance he needed. He won National League Rookie of the Year honors in 1992 and hit a Los Angeles franchise record 270 home runs in 12 seasons with the Dodgers.

DAVEY JOHNSON. In 1966, the rookie second baseman recorded the final hit against Dodger legend Sandy Koufax during the Baltimore Orioles's World Series sweep of Los Angeles. Johnson returned to Dodger Stadium as a manager and piloted the Dodgers in 1999 and 2000, posting a combined 163-161 record.

SEVEN
2000 and Beyond

When the Dodgers hosted their first Adult Camp in 1983, it was a chance for fans to live like baseball players for a week and learn from former Dodger greats, such as members of the Brooklyn Dodgers' famed "Boys of Summer" roster. But an interesting thing happened along the way as thousands of people from around the world visited the camp, which replicates the training routine and schedule of a regular major league camp.

Instructors who had been away from the Dodger organization or lived in different parts of the country rekindled their bonds as teammates. Many campers weren't satisfied with just one week in Dodgertown and decided to make it an annual trip, to either or both camps held every February and November.

"The friendships I make is the most exciting," said Elwin "Preacher" Roe, who pitched for the Brooklyn Dodgers from 1948 to 1954. "When you get to be my age, you really appreciate friends."

The campers and instructors talk baseball throughout the day, keeping alive the funny-but-true stories of training camp. For example, as a coach in the early 1970s, coach Tommy Lasorda was the victim of a prank pulled by several Dodgers, who painted his uniform green and left a note from "The Green Phantom," daring Lasorda to wear the green uniform. Later, "The Phantom" took credit for hiding the wheels from Walter O'Malley's golf cart under Lasorda's bed. At a barbecue, Jim Lefebvre emerged wearing a green outfit with a hood over his head. Lasorda ran toward the area to find out the identity of "The Phantom." He never reached his target as the players threw Lasorda into the swimming pool.

There were other stories of Dodgertown folklore, including farm director Fresco Thompson hiding in the woods with a flashlight, trying to discover which players were breaking curfew. And manager Walter Alston broke his 1955 World Series ring by pounding the door belonging to pitchers Sandy Koufax and Larry Sherry after they woke up Alston upon returning to the barracks.

"This is the most wonderful place in the world," said Clem Labine, a Dodger pitcher from 1950 to 1960. "The campers are number one. We're getting up there in age, but we're all kids again when we're at Dodgertown. The camaraderie you develop for one another becomes so important. That's why the Dodgers were so successful as a team. Camaraderie becomes more important than playing the game, it's the only thing that makes the game itself secondary, because guys are playing together for eight months."

The early Dodger teams of the 21st century featured outfielder Shawn Green, who hit a franchise-record 49 home runs in 2001, and Eric Gagne, who in 2002 experimented on the sidelines in Vero Beach, hoping to turn around his career as a failed starting pitcher. Former pitching coach Dave Wallace thought Gagne's hard-throwing makeup might be better suited as a closer. Because veteran Jeff Shaw had retired, the Dodgers could experiment. Gagne would become one of the most effective closers in major league history, converting all 55 save opportunities en route to Cy Young Award honors in 2003.

In August 2001, the City of Vero Beach and Indian River County purchased Dodgertown from the Dodgers. Changes to the landscape would be on the horizon, including the closing of the golf courses and the development of other portions of the land. Those changes, though, didn't affect the popularity of Dodgertown, which is continually ranked in the upper echelon of spring training sites by players and media outlets such as Baseball America.

Every September, the Dodgers stage an Instructional Camp for free agents and recent draft choices in order for young players to learn about the Dodger organization and gain a sneak preview of the spring training camp. In addition to baseball drills and conditioning, the staff at the Instructional Camp makes sure the young players learn about the history of their predecessors, whose pictures adorn practically every building on the base, along with the street signs saluting Hall of Fame players, managers, and broadcasters.

Dodger legend Maury Wills first reported to Vero Beach as a pitching prospect in 1951. On the initial day of workouts, players were assigned to groups based on their position. The 145-pound Wills noticed a line of taller, stronger athletes vying for a pitching spot. Then he noticed only one player was standing at second base. When a coach asked Wills for his position, his mind recalculated the odds and he replied, "I'm a second baseman."

For Wills, it would be eight long seasons in the minor leagues. He learned to become a switch-hitter in 1959 under Spokane manager Bobby Bragan. That Triple-A experience soon led him to play a major role with the 1959 World Champion Dodgers. Wills became a star with the Dodgers, swiping 104 bases during his National League MVP season in 1962. He played the banjo in talent shows in camp, a hobby that got him in trouble when he bolted the team during a 1966 goodwill tour of Japan and was photographed on stage playing at a nightclub in Hawaii instead of immediately reporting to his doctor's office in Los Angeles. Although traded to Pittsburgh, Wills returned in 1969 and spent the final four years of his playing career in a Dodger uniform.

"I first came to Dodgertown more than 50 years ago," says Wills, a spring training instructor. "When I walk around the camp, I can still feel the presence of those great Dodgers of the past and what it was like for a young baseball player to dream of life in the major leagues. I remember living in the minor league barracks for such a long time. You knew you had it made as a player if you were assigned to the major league barracks, with carpets and drapes and a private bath. But the memories come alive every trip to Dodgertown. Jackie Robinson, Roy Campanella, Duke Snider, Don Newcombe. As long as there is a Dodgertown, they will never be forgotten."

SAME GAME. Although the Dodger front office made changes under the FOX Group, the setting for an exhibition game at Holman Stadium remained the same. So was the familiar voice of Dick Crago, the public address announcer who started broadcasting for Vero Beach radio station WAXE in 1962.

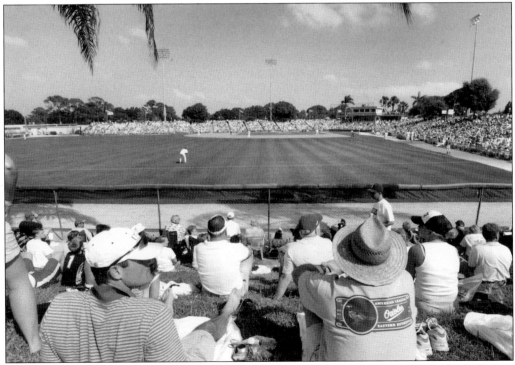

FAN'S VIEW. A benefit of spring training at Dodgertown is the opportunity to watch a ballgame on the grass hill beyond the outfield fence. There is also the inevitable mad dash for a souvenir when home runs soar out of the ballpark.

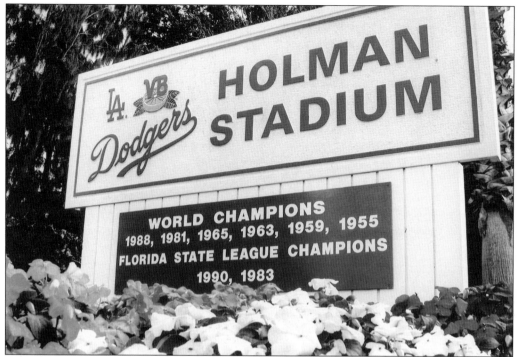

HOLMAN STADIUM. In addition to Dodger baseball games during spring training, the ballpark is home to the Single-A Vero Beach Dodgers of the Florida State League. The historic structure remained the centerpiece of Dodgertown when the City of Vero Beach purchased the baseball parcel for $19 million on August 29, 2001.

CASUAL DAY. One of the unique features of Dodgertown is the opportunity for fans to watch the Dodgers perform their spring drills up close. As players move from station to station along the complex, they frequently use the public walkways and other areas where fans assemble. This group will walk from Holman Stadium and across the bridge to field No. 2.

ISHII AND NOMO. Dodger pitchers Kazuhisa Ishii and Hideo Nomo flank their interpreter, Scott Akasaki, during spring training in 2002. Los Angeles signed Ishii as a free agent after his 10-year career with the Yakult Swallows of the Japanese League. Nomo and Ishii combined for 30 victories in 2002.

JACK CLARK. The former hitting star of the San Francisco Giants and St. Louis Cardinals served as the Dodger batting coach from 2001 to 2003. Many of the instructors at Dodgertown use bicycles to roam around the complex, and use the handy transportation for a cruise back to the villa at the end of the work schedule.

ROYAL TREATMENT. Coming off a 52-save season, bullpen ace Eric Gagne enjoys some horseplay with teammate Paul Quantrill upon his arrival in 2003. In his second year as a reliever, Gagne converted all 55 save opportunities in 2003 en route to the Cy Young Award.

RIBBON CUTTING. Celebrating the opening of the new Dodgertown training facilities in 2003 are County Commissioner Ken Macht, Dodgertown director Craig Callan, manager Jim Tracy, and County Commissioner Art Neuberger. The 30,000-square-foot building includes clubhouses, training facilities, and executive and administrative offices adjacent to Holman Stadium.

MAIN BUILDING. This is the entrance to the Dodger training facility, with the latest state-of-the-art equipment and technology. Renovations were also made to existing fields, along with the construction of four new indoor batting/pitching tunnels and a new major league pitching and bunting area.

BABY BLUE. Outfielder Shawn Green cradles his newborn daughter, three-month-old Presley, in the Dodger clubhouse during spring training in 2003. Green's 91 home runs in 2001 and 2002 are the most by a Dodger in consecutive seasons in team history. Green eclipsed the previous mark held by Duke Snider, who hit 85 home runs in 1955 and 1956.

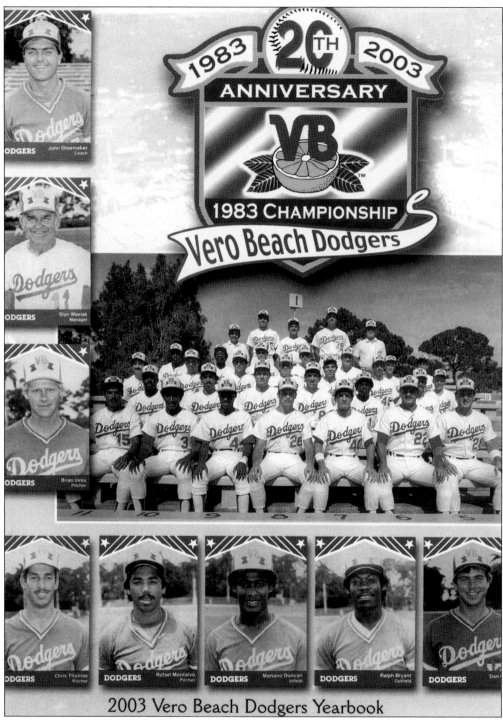

2003 Vero Beach Dodgers Yearbook

ANNIVERSARY. In 2003, the Dodgers dedicated their program to the 20th anniversary of the 1983 Vero Beach Dodger team, which defeated Ft. Myers and Daytona Beach to win the Florida State League championship. Future Dodgers on that 1983 squad included infielder Mariano Duncan and outfielder Ralph Bryant.

SCENIC WALK. Dodgertown residents usually take this path to breakfast every morning, walking along a path that leads to the dining room on the right. The street lamps are decorated with painted red stitching, which simulate glowing baseballs at night. The corridor beyond the first door leads to the minor league clubhouse, a laundry room, and administration offices.

INSTRUCTIONAL LEAGUE. As the major leaguers battle for the pennant in September, top rookies and other first-year players receive special instruction at Dodgertown. In this September 2003 camp, pitcher Chuck Tiffany works on his delivery with coach Rick Honeycutt.

SPRING ARRIVAL. New Dodger general manager Paul DePodesta greets outfielder Shawn Green as vice president Tommy Lasorda looks on during the early days of spring training in 2004. The Harvard graduate had been an assistant to Oakland Athletics general manager Billy Beane since 1998.

TIME FOR LAUGHS. Catcher David Ross enjoys a light moment with pitcher Hideo Nomo during a break in the Dodger batting cages. Ross hit 10 home runs in just 40 games for the Dodgers in 2003.

PAT SCRENAR. The Dodgers' physical therapist checks on pitcher Kazuhisa Ishii in the Dodgertown medical facility. Screnar joined the Dodgers in February 1981 and develops therapy programs for injured players and plans individual exercise programs. He was instrumental in Orel Hershiser's comeback from reconstructive shoulder surgery in 1990.

TOP DOCTOR. The Dodgers dedicated their medical facility in honor of team physician Dr. Frank Jobe in 2004. Thirty years earlier, Jobe performed the first "Tommy John surgery" on the Dodger pitcher, whose career was threatened by an elbow injury.

BATTING CAGES. This indoor facility ensures poor weather won't stop hitting drills during spring training. Every inch of Dodgertown is used to develop players.

QUIET TIME. Away from the glare of the bigger fields, Joe Thurston and Dave Roberts fine-tune their bunting skills in a batting cage dedicated to Maury Wills, the former Dodger stolen-base artist whose base-running skills revolutionized the game in the early 1960s.

OFF TO THE RACES. During a February morning meeting in 2004, coach Glenn Hoffman holds a photo of Dodger manager Walter Alston and his players on bicycles during spring training in 1970. As camp coordinator, Hoffman keeps the mood loose at times, organizing bicycle races and a bowling league in town for players and team officials.

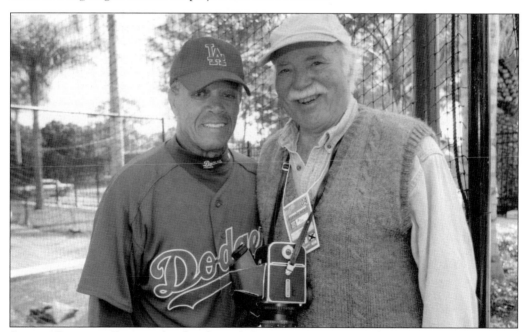

SWEET PHOTOS. During the heyday of *Sport Magazine*'s popularity in the 1950s, the publication's cover photos usually belonged to Ozzie Sweet, whose portraits captured the images of famous athletes. In 2004, Sweet reminisces with Maury Wills, the Dodger speedster who frequently graced the magazine's cover when the Dodgers won three pennants and two championships from 1963 to 1966.

FIRST PITCH. New Dodger owner Frank McCourt throws out the ceremonial first pitch prior to an exhibition game with the New York Mets at Holman Stadium on March 2, 2004. The Boston real estate developer purchased the Dodgers in a deal that includes the lease on Dodgertown and the club's academy in the Dominican Republic. McCourt pledged to return family ownership to the Dodgers, which were owned by the O'Malley family from 1950 to 1998. McCourt's grandfather was a minority owner of the National League's Boston Braves in the 1940s and his mother attended the 1948 World Series when the Braves faced the Cleveland Indians.

FOREVER YOUNG. At age 89, retired sales executive Herb Lewis made his 17th appearance at the Dodger Adult Camp in 2004. "My dad always said age was just a number," Lewis said. "I love coming to Dodgertown and seeing my friends." Back home in Southern California, Lewis also plays second base on Sundays with Dodgertown West, a group of "veterans" from previous Dodger Adult Camps.

ROOKIE PROSPECTS. Dressed in their Vero Beach spring training Dodger T-shirts and caps, these youngsters are ready for a day at the ballpark. Whether it's played in the back yard or in a major league stadium, baseball remains a game for all generations.

SPRING OPTIMISM. Pitcher Orel Hershiser looks forward to more success in 1986 following his breakthrough 19-victory season with the Dodgers. Who could predict that in just two years, Hershiser would author a record streak of 59 consecutive scoreless innings, win a Cy Young Award, and earn MVP honors in both the League Championship Series and World Series.